IMAGES
of America

LITITZ

On the cover: Residents of Lititz gathered in 1910 at the Moravian Brothers House to celebrate the installation of a plaque reminding the public of its part in the Revolutionary War. The plaque reads, "In Memory of the Brave Soldiers of the Continental Army who died in this building when it was used by order of General Washington as a military hospital from December 19, 1777 to August 28, 1778. This tablet is erected by the Lititz Moravian congregation. Of the 450 men quartered here, there died 120, of whom 110 were buried near the eastern limit of the settlement." (Courtesy of Lititz Moravian Church.)

IMAGES
of America

LITITZ

Kathy Blankenbiller

ARCADIA
PUBLISHING

Published by Arcadia Publishing
Charleston, South Carolina

Printed in the United States of America

Library of Congress Control Number: 2008935290

For all general information contact Arcadia Publishing at:
Telephone 843-853-2070
Fax 843-853-0044
E-mail sales@arcadiapublishing.com
For customer service and orders:
Toll-Free 1-888-313-2665

Visit us on the Internet at www.arcadiapublishing.com

*Dedicated to the people of Lititz
who have welcomed me and have changed my life forever.*

CONTENTS

Acknowledgments 6

Introduction 7

1. Forgotten Seasons 9

2. Who Are the Moravians? 15

3. Education and Music 29

4. Worldliness 43

5. War 65

6. Picture Perfect Memories 83

ACKNOWLEDGMENTS

Conducting research to uncover little-known facts about a town's history, authors begin by carefully searching all recorded documents for accuracy. The most important, most interesting facts, however, always seem to come from the community itself. That is, the local history that is kept alive by word of mouth. From the beginning, I knew that finding those few people who have the "inside" stories would be quite a feat in itself. A few fervent prayers, however, and I was on my way.

Angels, they say, walk among us. Usually we cannot recognize them, but I'm one of the lucky few that know exactly what angels look like. You see, when I needed them most, my angels—my friends—were right beside me.

When Erin Vosgien of Arcadia Publishing approached me with this opportunity to author the book I'd dreamed of producing, I jumped at the chance. She is my first angel, offering me a dream then patiently guiding me through it. My band of angels includes: Thelma Buchter, Gladys Crowl, Claire dePerrot, Dale Groff, Donna Hammond, Bernie Hendricks, Peggy Jones, Randy Miller, Jim Nuss, the Lititz Historical Foundation, Dale Shelley, Corey and Charlene Van Brookhoven, and Marion Weaver—thank you for sharing your beloved collections and memories. To George Sayles of the Photographer's Corner, thank you for your generosity, above and beyond what any friend could expect. To my dearest angels, Ron Reedy and Cyndy Scibal, heartfelt appreciation for the photographs and humble gratitude for your patience, instruction, and unending encouragement. To all my helpful friends too numerous to name individually, I thank you all from the bottom of my heart for helping me to make this book a reality. Thank you too, to my family for their love, hours of assistance, and incredible support. And to the wonderful people of Lititz, you have made my life fulfilled by reaching out to me and sharing your town with me; at last I have a hometown to call my own. I thank you all. My most important thank you, of course, is to my sweet Lord, who made all this possible.

INTRODUCTION

The Lititz area was inhabited many centuries ago by Native Americans. Relics from their cultures have been unearthed near the headwaters of the Lititz Springs, thus sustaining the conclusion that this pristine wilderness of scenic serenity had had cultural development and social organization long before the arrival of the European settlers.

In 1722, Christian Bomberger became the first known European settler in the Lititz area. Another early settler was Richard Carter, who emigrated from Warwickshire, England, who became a prominent figure in the early life of the region and in 1729 named the area Warwick Township.

In 1742, Count Nicholas Ludwig von Zinzendorf of Saxony, the leader and organizer of the modern-day Moravian Church, was searching for a tract of land to establish a religious community similar to those in Bethlehem and Nazareth, Pennsylvania. He stopped to preach at the tavern of Jacob Huber, located north of Lititz. John George Klein, who was not in attendance at the tavern, followed Count Zinzendorf to Lancaster the next day to hear him preach. At Lancaster, Klein was won over by the Count's cause and was inspired to turn over his tract of land, consisting of 491 acres that meandered along Carter's Run; these 491 acres became the new settlement.

On June 12, 1756, a letter from Europe addressed to the Moravian Brethren was received from Count Zinzendorf, in which he named the new settlement Litiz, which was the German spelling. The name that was given was in commemoration of the Castle of Lidice and Citadelou, located in Eastern Bohemia near the Silesian/Moravia border where the early Moravian Brethren found refuge in 1456.

In 1757, the town of Lititz was surveyed and laid in lots. The administration and supervision of the community was entirely by the Moravian congregation and would continue until 1855. Everything relating to village life, including religious, social, and economic, was under the supervision and control of the governing authority of the congregation.

Only Moravians were permitted to live in the village and build homes on the land owned by the church for which they paid rent into the congregation treasury. The end of the lease system probably started when the members of the congregation came in contact with those from the outside world. The contacts stemmed from the pupils, parents, and friends of the John Beck Boys' Academy and the Linden Hall Seminary Girls' School. This contact had much to do with the growing dissatisfaction of the restricted community life of the village. The settlement system had lost the vitality of the early years, and strong pressure was beginning to be felt for its abolition.

It became evident that by the end of the first 100 years of the founding of Lititz, community life was changing. Consequently in 1855, it was decided to make Lititz an open community. Members of other Christian fellowships took up residence and their churches soon followed. The Reading and Columbia Rail Road came in 1863; this important means of transportation was a great factor in encouraging new industries and enterprises to locate in Lititz.

From the very early days, Lititz has been noted as an industrial town. The Moravian congregation as an organization had a sawmill, gristmill, general store, tavern, potash factory, apothecary's shop, and several farms. One of the most famous items made was the pretzel, which was commercialized by Julius Sturgis in 1861.

Lititz grew as industry increased; the rails, transportation, manufacturing facilities, homes, schools, and places of worship abounded during this era. Truly Lititz was becoming one of the most beautiful, healthy, and prosperous towns in the United States.

Lititz has one of the oldest continuous Fourth of July celebrations in the nation, which was established in 1818. Unique to the celebration is a special attraction of illuminating candles, which started in 1843, was introduced to raise funds for improvements to the park. Celebration planners decided to light 400 candles; today 7,000 candles are lit as a grand illumination to end the day's festivities.

Gen. John Augustus Sutter, an early pioneer of California who founded the town of Sacramento in 1839, became one of Lititz's notable citizens. The California gold rush of 1849 occurred over General Sutter's many tracts of land. Losing his ownership of land in California in 1865, he finally settled in Lititz in 1871 living out the rest of life until his death in June 1880. His burial is in the Lititz Moravian Cemetery.

This photographic book, titled *Lititz*, along with historical documentation covering three centuries, is the enthusiastic work of Kathy Blankenbiller, who appreciates her adopted community of Lititz and is extremely proud of its heritage. Kathy depicts a diversified community, which is nestled amid the fertile farmland of Lancaster County, Pennsylvania.

Lititz has a hearty body of citizens, who are favored with a refined community life that embodies a widely acclaimed religious and historical heritage. Lititz, with its incomparable beauty and its scenic serenity, is certainly a place of community pride.

—R. Ronald Reedy, Lititz historian

One

FORGOTTEN SEASONS

Jacob Huber's Tavern, now known as the Forgotten Seasons Bed and Breakfast, sits unobtrusively along East Newport Road, a silent sentinel of Lititz's past that is rarely noticed. Huber, a German immigrant, made a significant contribution to the development of bucolic south-central Pennsylvania, beginning with the building of a home and tavern via land that was warranted to him around 1735 from John, Thomas, and Richard Penn. A log cabin home, measuring 18 feet by 20 feet, was first, then the tavern next, adjacent to the cabin, which now serves as the bed-and-breakfast. It is in this tiny building, so rich in history, that the people who would help shape northern Lancaster County came to visit.

Huber, regarded as a prominent businessman, was commissioned by the county of Lancaster in the late 1730s to survey and suggest improvements for Newport Road from Mount Hope to the Spring Garden area and later, to participate in another survey and recommendation for improvement of the road from the town of Lancaster toward Tulpehocken. Huber's recommendations were made and accepted in 1740. Today Route 501 follows roughly the same path as this road from the courthouse in Lancaster to Tulpehocken, mentioned above. It is of great interest to note that this same road passed through the property of Huber's neighbor to the north, George Kline.

It was in December 1742, that Count Nicholaus Ludwig von Zinzendorf, leader of the renewed Moravian Church, traveled from Bethlehem to Oley to Tulpehocken, passing through Kline's property, to stay at Jacob Huber's Tavern. Zinzendorf had devoted this journey to finding a suitable location to start a mission to minister to the Native Americans and German settlers so the very evening of his arrival at the tavern, he spoke to Huber's neighbors about his vision to create a Godly settlement, away from all worldliness. It would be the landowner adjacent to Jacob Huber's Tavern, Klein, who would later donate 491 acres of his land to the Moravian Church. Present-day Lititz is situated on what was once Klein's land.

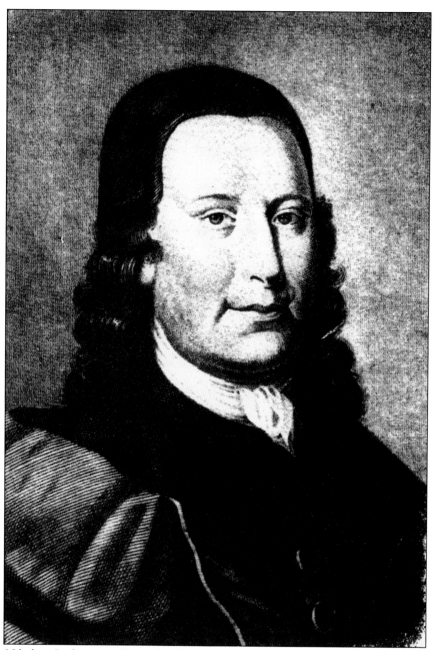

Count Nikolaus Ludwig von Zinzendorf of Saxony, Germany, was introduced to the Moravian culture in 1721; by 1727, he had become a Moravian bishop. Many proclaim "Papa" Zinzendorf as the "father of modern missions," for it was he who was the first to send missionaries out worldwide. Called to the Warwick, Pennsylvania, area in 1742 to preach, the result was an offer of land at the cost of £70 per year if he would bring a Moravian settlement to the area. By 1755, Moravians had arrived. Count Zinzendorf named the new Warwick settlement Litiz (early spelling) on June 26, 1756, in commemoration of the Castle of Lidice and Citadelou, located in northeastern Bohemia near the Silesian/Moravia border, where early Moravian Brethren found refuge in 1456. (Courtesy of Lititz Moravian Church.)

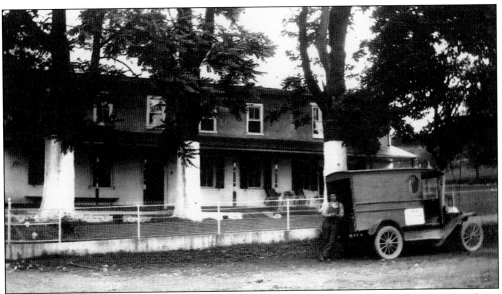

When Zinzendorf arrived in 1742, he stayed and preached at Jacob Huber's Tavern, seen above in a 1920s photograph. The inn was built along the path of an old Native American trail that developed into a road used for carrying goods and merchandise between the frontier and the seaport in Newport, Delaware. Huber's Tavern was one of the taverns built approximately every 10 to 15 miles along what is now known as Newport Road. Dale and Suzanne Groff purchased the building in 2001 and reinvented it as Forgotten Seasons Bed and Breakfast. Recently sold to new owners, it remains a historic bed-and-breakfast that welcomes curious guests from around the globe. (Courtesy of Dale Groff.)

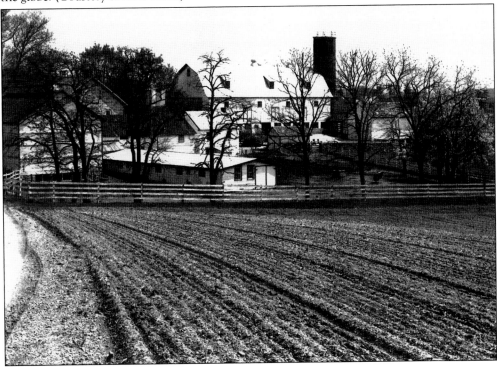

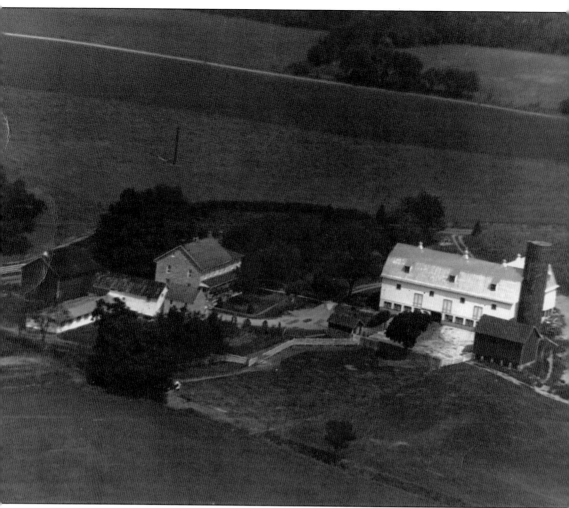

There were major renovations made to the property in the 1940s when owner Paul Hershey owned the estate that Jacob Huber once called home. The north view of the property seen here in an aerial view was taken in the 1950s. It shows the tobacco shed on the immediate left side along Newport Road, the house, the springhouse across from it, and the huge, white barn that had been constructed in the 1800s. The barn originally had a flat roof but Hershey rebuilt it, as seen in the photograph. Note the terra-cotta silo. In 1995, farmland on the property was sold to be developed into housing; Newport Road was rerouted from the north side of the house to the south, causing everything seen on this photograph to be destroyed except for the house. (Courtesy of Dale Groff.)

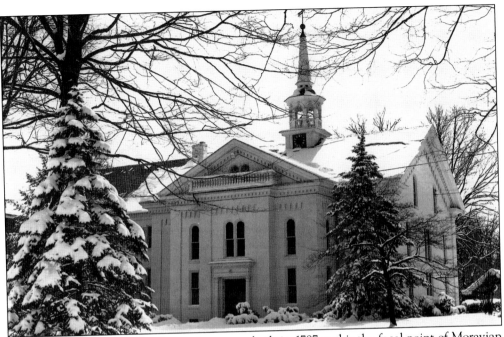

The Moravian Sanctuary in Lititz, above, was built in 1787 and is the focal point of Moravian Church Square. It sits as a gentle sentinel, watching over Lititz for more than 220 years. Below is the large, main building of Linden Hall, far left, a portion of which was built in 1767, and the Sisters House, center, built in 1758. Off to the far right is the Lititz Moravian Sanctuary. The full layout of church square includes the Mary Dixon Chapel to the left of Linden Hall (not pictured); the Moravian Sanctuary, 1787, to the opposite side of the Sisters House; followed by its neighbor, the Brothers' House, 1759; and lastly, the Moravian Archive Building, 1908 (both out of frame). Each of the structures was set close to the edges of the open square, and all were constructed of stone. (Courtesy of Lititz Moravian Church.)

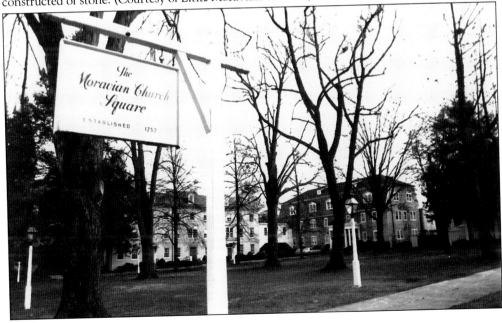

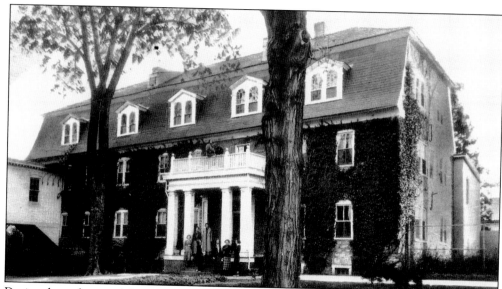

During the early years, Moravians abided by the "choir system," in which congregational members who shared the same life experiences, such as age, gender, and marital status, were grouped. The women were termed "sisters" and the men, "brothers." Single sisters had the opportunity to live in the Sisters House, above, and single brothers in the Brothers House, seen below. Here they worshiped, ate, and were educated together. Each house was self-sustaining through the products they made and sold and through the farms they tended in back of the two houses. Both photographs are from around the 1800s. Today the Sisters House serves as a residence for a portion of the Linden Hall staff while the Brothers House continues to be used as a meetinghouse for the Moravian Church. (Courtesy of Lititz Moravian Church.)

Two

WHO ARE
THE MORAVIANS?

Founding fathers of Lititz had their roots in Moravia and Bohemia, what is now recognized as the Czech Republic. The Moravians, as these people would later come to be known, were borne out of the teachings of John Hus, a Bohemian religious reformer and martyr whose beliefs were strongly tied to 14th century Oxford professor John Wycliffe. Wycliffe was opposed to the teachings of the organized church and held the strong belief that the Bible should be able to be read in the common language of the people, which Hus implicitly supported 100 years later. The Catholic Church despised the uprisings Hus caused by his "radical" views and preaching that the practice of faith was best shown through the actions of one's daily life and especially Christian love, nonviolence, and simplicity. Hus was excommunicated in 1411 and burned at the stake on July 6, 1415. Sadly, after his death, his followers, dubbed Hussites, were fanatically persecuted for following Hus's teachings. Unknown to the Catholic Church, however, a hidden seed of his believers still remained. In 1457, his followers gathered outside of the Castle of Lidice and Citadelou and organized themselves into the Unitas Fratrum or United Brethren.

In 1722, Count Nicholas Ludwig von Zinzendorf, a highly educated, Pietist Lutheran German noble, through an acquaintance with Moravian Christian David, provided sanctuary on his land in Saxony, Germany, for any Moravian who feared religious persecution. The peaceful Moravians found their way to Zinzendorf's haven and created a community, Hernnhut, which grew quickly. Zinzendorf studied the Moravians vigorously, eventually becoming a bishop and finally the patron of the Moravians' Renewed Church of the United Brethren. Mission fervor ensued.

Zinzendorf traveled to the Warwick area of Pennsylvania in 1742 to preach to local farmers who had issued a request for spiritual guidance. So taken by the Moravian speaker, resident John George Kline offered 491 acres of his land so that a Moravian settlement could be created. Lititz was originally planned to be a religious environment that would shun worldliness and was a closed mission-supporting society for almost 100 years.

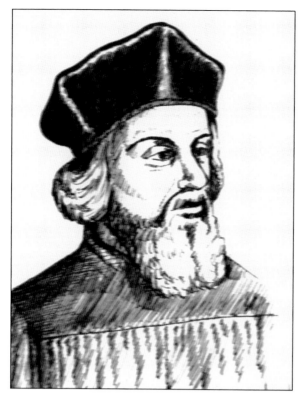

John Hus, left, was ordained as a priest in 1402 and against the pope's decree, preached his sermons in the Czech tongue instead of Latin. Hus gained many followers by preaching in the peasant tongue and challenging the pope's practice of selling indulgences to raise money for the church. He was later imprisoned and in 1415 burned at the stake. His small band of followers eventually evolved into the Moravian Church. (Courtesy of Lititz Moravian Church.)

This memorial was erected in Naarden, Netherlands, in memory of Jan Amos Comenius, "the father of modern education." Comenius, the last bishop of the community of the Moravian brothers, wrote in 1632, "not the children of the rich or of the powerful only, but of all alike, boys and girls, both noble and ignoble, rich and poor, in all cities and towns, villages and hamlets, should be sent to school." (Courtesy of Glans deBruijn.)

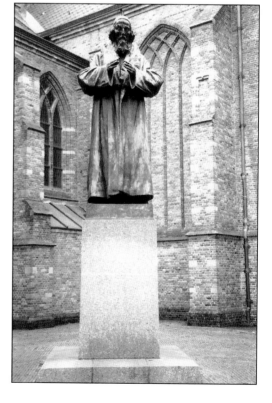

The sanctuary, shown here decorated for Easter in 1908, is of the prophetic style with a high pulpit on which is the open Holy Bible. Above the pulpit is a stained-glass window of the Moravian seal and motto, a picture of a lamb representing Jesus Christ or Dei (Lamb of God) carrying a flag with a cross. The Latin words *Vicit agnus noster eum sequamur*, translated "Our Lamb has conquered; let us follow him," encircle the image. (Courtesy of James Nuss.)

In 1857, the building was remodeled, with the pulpit recess and vestibule added, the pitch of the roof changed, stationary pews added, and frosted-glass windows installed. In 1892, stained-glass cathedral windows replaced the older panes. Originally lit by a tin chandelier that hung from the center of the ceiling, the church's lighting system has progressed from tallow candles, to sperm oil, to kerosene lamps, to gas, to electricity. (Courtesy of Lititz Moravian Church.)

Moravians are credited with holding the first candlelight services on Christmas Eve. In 1741, during the first Christmas in Lititz, Count Nicholas Ludwig von Zinzendorf lit a candle during services to symbolize the "Light of the World" and sang hymns with the congregation. It is tradition in the Lititz Moravian Church that after each person has a lit candle, lights of the church are darkened and a 110-point Moravian star hanging over the pulpit begins slowly to glow until its light fills the room. It is an experience that touches the soul. The star's design was obtained from Germany, reproduced in Lititz, and first hung in the church in 1980. It originated in Moravian boarding schools in Niesky, Germany, in the 19th century as an exercise in geometry. (Courtesy of Lititz Moravian Church.)

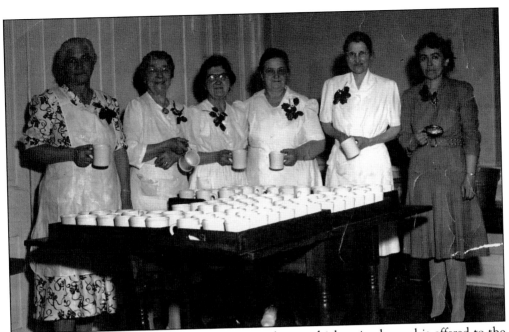

The Moravian "lovefeast" is an act of fellowship during which a simple meal is offered to the congregation during the ceremony. After everyone has been served, a prayer of thanks is given, and the food and drinks are consumed. Helping out in years past are (above), from left to right, Mrs. Adam Showers, Sallie Habecker, Mabel Schaerer, Amanda Miller, Marian Boxman, and Margaret Miller. Beeswax candles, below, passed out to the Lititz congregation and lit near the end of the Christmas lovefeast, are considered the purest kind of wax, representing Christ's purity and the flame that Jesus kindles "in each believing heart." Lititz Moravian congregational members volunteer each year to prepare 6,000 candles in the manner of the old church. (Courtesy of Lititz Moravian Church.)

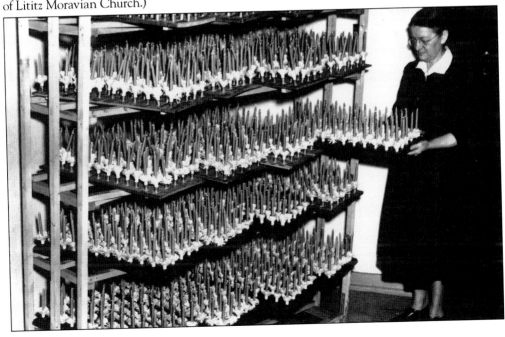

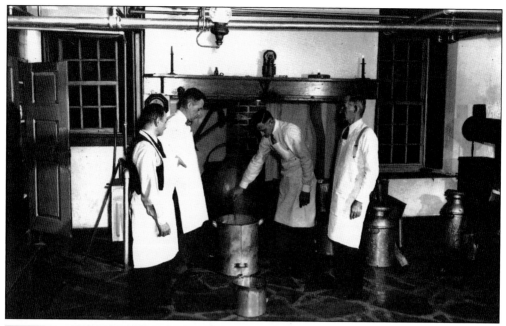

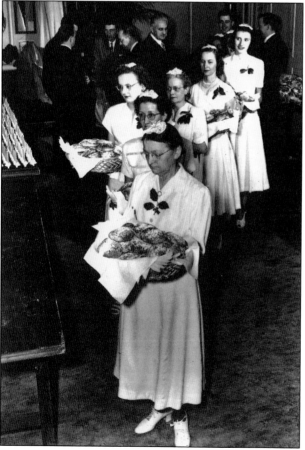

Located in the basement of the Moravian parsonage is the coffee kitchen, where coffee for the lovefeasts was made until 1957. The kitchen was restored in 1943, but great care was taken to preserve the old atmosphere. Original butterfly and rosette hinges remain, as well as spoon latches on the doors. Coffee for the ceremonies is now made upstairs in the preparation room. At left, *Dieners*, German for "servers," make their way out to the Lititz congregation during a Christmas Eve lovefeast. During the service, members of the Lititz congregation receive a pastry referred to as a lovefeast bun and their choice of a cup of coffee or chocolate milk. As they partake, the choir sings. (Courtesy of Lititz Moravian Church.)

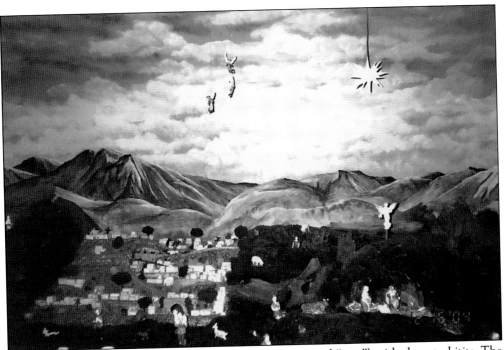

Early German-speaking settlers brought the putz (pronounced "puts") with them to Lititz. The display is a scene using miniature figures in landscapes made of varying natural materials to depict the story of Jesus's birth. It is said that such a putz was placed on display in Lititz in 1761, perhaps making Lititz the beginning of this tradition—the Christmas putz, or *Die Weihnachtskrippe*. (Courtesy of Lititz Moravian Church.)

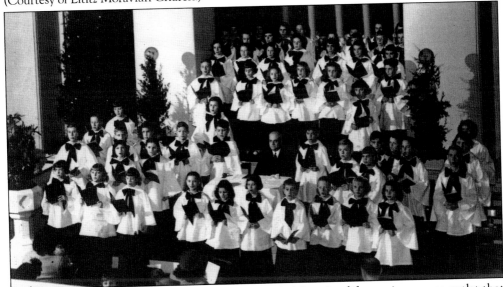

Unlike many pleasures that were not seen fit in early Moravian life, music was one outlet that was encouraged. Youngsters were proud to join the children's choir to "make a joyful noise" and were raised with music, receiving instruction in reading, writing, and composing music. Moravian anthems and solos used during religious gatherings are of utmost importance as the sermon is presented through the texts of the hymns. (Courtesy of Lititz Moravian Church.)

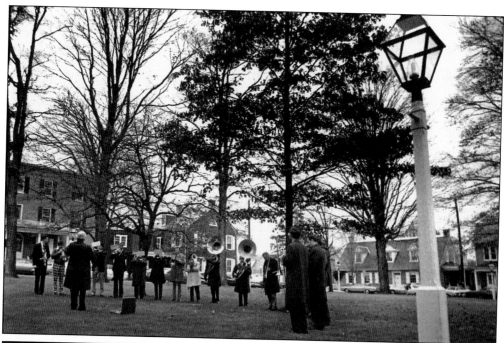

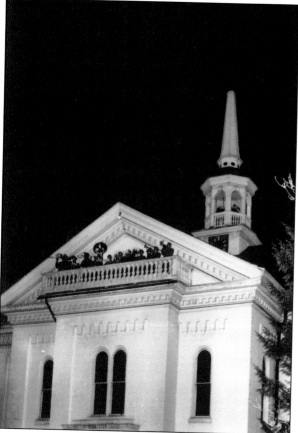

The trombone is used during joyous as well as solemn Moravian occasions. Other brass pieces were added when valved instruments were created. In the 18th and 19th centuries, it was tradition for the Moravian Church trombone choir to announce the death of a member of its congregation by playing a chorale from the balcony of the church spire. The Lititz Moravian trombone choir no longer climbs to the spire but continues the tradition by playing the same chorale in the Sunday service following a member's death. (Courtesy of Lititz Moravian Church.)

German immigrant David Tannenberg moved to Lititz in the early 1760s and built the organ, right, that was used in the dedication of the new sanctuary in 1787. The organ was used until 1879; it has since been restored and now resides in the church. George Washington and members of Congress attended the dedication of a Tannenberg organ at Zion Lutheran Church in Philadelphia. (Courtesy of Lititz Moravian Church.)

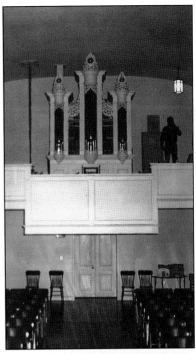

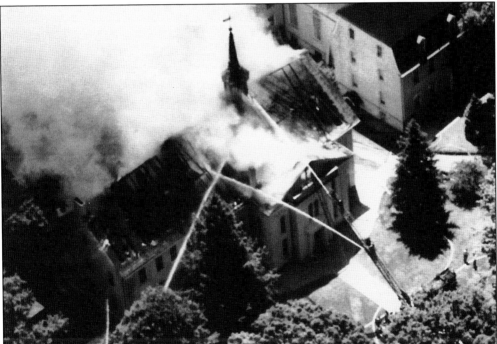

Renovations to the interior and exterior of the Lititz Moravian Church sanctuary came to a horrifying halt in an early afternoon in 1957 when a spark from a worker's blowtorch set the roof of the church afire. Seven area fire companies and the Lancaster City Fire Department assisted the Lititz Fire Company; within four hours, the roof beams and the steeple buckled and fell into the middle of the sanctuary. (Courtesy of Lititz Moravian Church.)

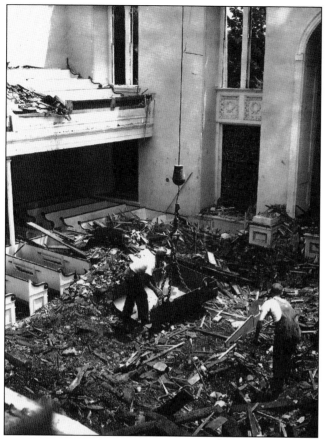

It was estimated that the damages were almost a quarter of a million dollars. Rebuilding included the replacement of the church belfry, which had been designed by David Tannenberg; his original plans were used again to build a new, stronger steeple. Pastor of the church, Rt. Rev. Carl J. Helmich, below, stands in the ashes from the inferno. On vacation at the time of the fire, he returned to find his church in ruins. The Reverend Helmich found that, thanks to the efforts of the firefighters and volunteers, much of the church's contents had been carried to safety and adjoining buildings were not damaged. Lititz Moravian Church, built in 1787 and designed by William Henry of Lancaster, was rebuilt. (Courtesy of Lititz Moravian Church.)

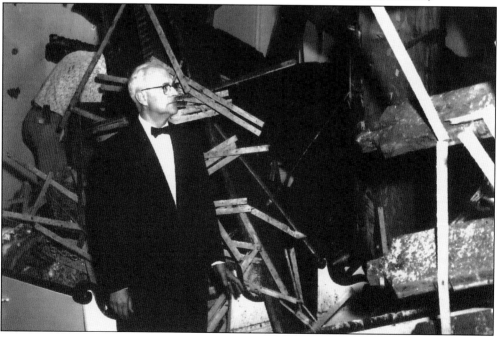

In 1874, Julius F. Sturgis donated a lot on East Orange Street to the Evangelical Association. By November 29 of that same year, the association, now renamed Jerusalem Church of the Evangelical Association, was dedicated. It was the first "outside" church to begin holding services in Lititz since the closed society had begun to welcome non-Moravians to town. In 1896, it was renamed Trinity United Evangelical Church. (Courtesy of the Robert "Sketch" Mearig collection.)

Christian Fenstermacher, a Philadelphian, arrived in 1764 to open a general store in Lititz at 120 East Main Street. However, in 1787, Brother Payne arrived from Bethlehem and took over the store, above, at which time it became the property of the Moravian Church, renaming it the Congregational Store. Constructed in 1762, it stands today, home of Hannah Bruce Bears and Teddy Hospital and the Beck Real Estate office. (Courtesy of Lititz Historical Foundation.)

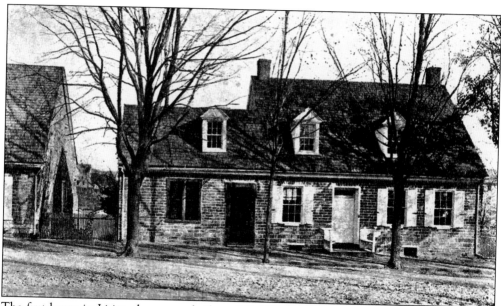

The first home in Lititz, above, was built at 137–139 East Main Street in 1740 but was rebuilt in 1792 as a dye house for Johannes Mueller, the town dyer. In 1794, the original dye house was replaced by a log addition to the left of the original dwelling. The stone portion was used as Mueller's home, the log portion as his shop. Next to the Mueller house is a home built by Christian Schropp in 1793, at 145 East Main Street. Schropp was a nail smith, schoolteacher, and musician. Between 1900 and 1914, the building was renovated; it now serves as the Lititz Museum, which is open to the public on a seasonal basis. Tours of the Mueller home are given by costumed guides. (Courtesy of Lititz Historical Foundation.)

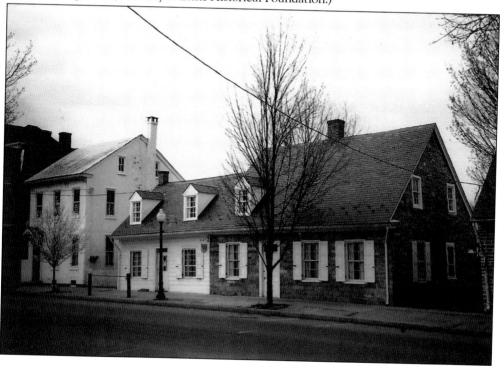

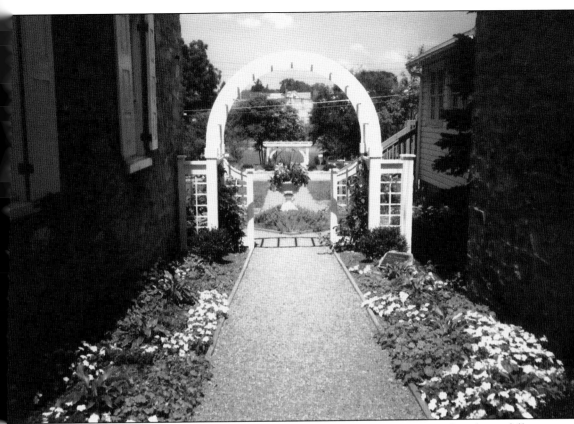

The Mary Oehme Gardens, located to the rear of the Lititz museum, provide a beautifully landscaped setting for quiet contemplation or to rent for any number of special events including corporate affairs, weddings, and receptions. Guests enjoy the harmony of design and the innovative use of the site, which offers an authentic heritage garden, water garden, and a pleasing, diverse mixture of colors, textures, and plants that create a delight for the senses. (Courtesy of Lititz Historical Foundation.)

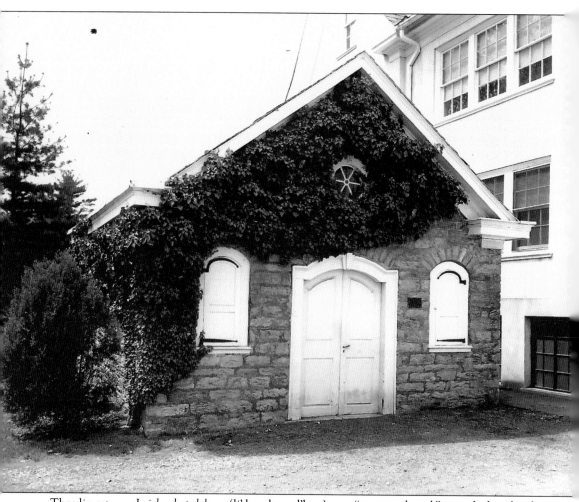

The limestone *Leichenkapelchen* (li'-hen-ka-pel'hen), or "corpse chapel," stands beside the Moravian sanctuary, although no longer in use. Built in 1786, bodies of deceased congregational members were brought here for funeral services then interred; it has never been the practice in older Moravian congregations to take a body into the church. Viewings now take place next door in the Brothers House. An interesting aspect of the Leichenkapelchen is the creation of two round windows, which aide in fresh, cooler north-side air to enter and be drawn across the earthen floor. The air leaves through the portal vent hole high on the south wall, where a vacuum is created due to warmer air rising outside. This creates a venturi effect or 18th-century air conditioning. (Courtesy of Lititz Moravian Church.)

Three

EDUCATION AND MUSIC

The educational aspect of Lititz history must begin with the Moravians, founders of Lititz, who viewed education as a sacred responsibility, believing that education should allow each individual to develop fully in mind, body, and spirit. As in every Moravian settlement, one of the first buildings to be erected was a structure to be used as a school. In Lititz, a *Gemeinhaus*, a building used as a parsonage, meetinghouse, and school, was built immediately. From this was borne Linden Hall Seminary for Girls in 1746 and John Beck School for Boys in 1815. The public school system was not in place in Lititz until 1852, when Lititz was organized as an independent school district under the common school system of Pennsylvania.

A primary school was opened on January 5, 1853, although the "advanced" girls were sent on to Linden Hall Seminary for Girls and the "advanced" boys to John Beck's School for Boys. Tuition to those private schools was paid for by the Lititz School District. In 1870, the first public grammar school for both boys and girls opened at the corner of South Cedar Street and Juniper Alley; high school classes began there in 1885. The old 1870 school is gone, rebuilt in 1918. This remained the only school in town until 1956 when the new Warwick High School was occupied. Warwick Middle School followed, opening in September 1971.

Beck's School for Boys ceased operations in 1865, but Linden Hall Seminary for Girls prospered and now, over 260 years later, claims the title of the oldest continuously operated girls' boarding school in the United States.

Moravian churchman and educator John Amos Comenius viewed education as an instrument of salvation; the soul had to be trained to search for truth and to recognize it when it was found. Moravians considered every human soul a potential candidate for salvation, therefore every human being had to be educated. (Courtesy of Lititz Moravian Church.)

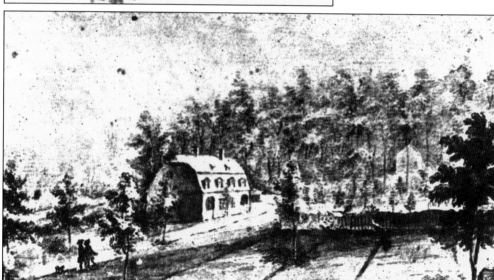

Plans for the original Warwick Gemeinhaus, a structure to be used as a school, meetinghouse, and a home for the local minister and his wife, began in 1746. On May 24, 1748, Rev. Leonard Schnell occupied the house, and lessons began for four boys and three girls. The building was taken down and relocated closer the center of town in 1766; this was the foundation of Linden Hall. (Courtesy of James Nuss.)

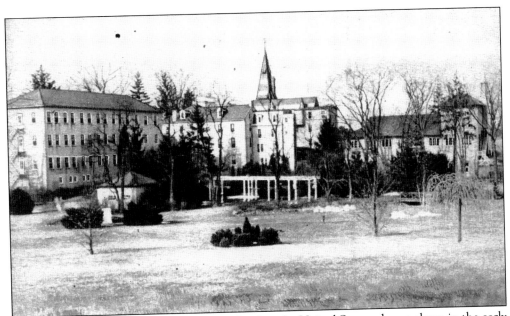

Linden Hall, the oldest all-girls boarding school in the United States, shown above in the early 1900s, is located adjacent to the Moravian church. Founded by the Moravians in 1746, today it offers one of America's strongest academic college-preparatory programs for girls in grades 6–12. In 1766, after the Gemeinhaus was taken down and rebuilt at the northeast corner of Water and Main Streets, boys attended school at that location while the girls' school took place in the Sisters House. By 1769, the number of students indicated the need for a larger facility to be built, as shown below. This building is now occupied by the school's administrative offices. (Courtesy of Randy Miller.)

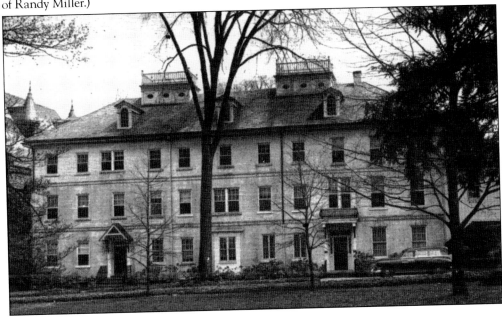

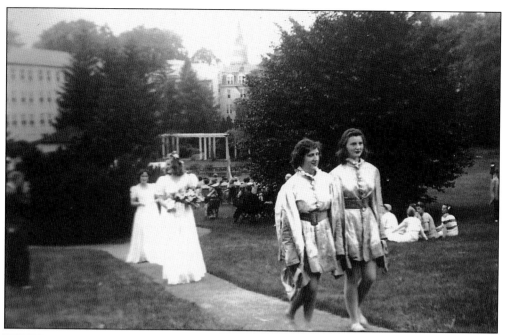

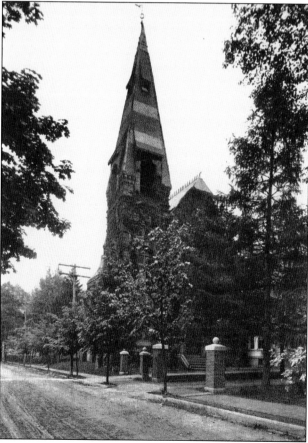

Linden Hall welcomes girls from around the world who become "sisters" during their years at the historic school thanks to its devotion to providing a structured, family-centered environment. Weekdays are balanced by weekends of relaxation, socializing, and other activities. Shown in the photograph above is the crowning of the May Queen, led by her heralds during the May 30, 1942, May Day celebration; in the center background is the spire of the Mary Dixon Chapel, seen below. It was dedicated on February 24, 1885, and built in memory of Mary Dixon, an 1879 Linden Hall graduate. After her death at age 19 in 1882, her father had the chapel built at a cost of $23,000. Mr. Dixon never lived to see it completed; many say he died of a broken heart. (Above, courtesy of Claire dePerrot; left, courtesy of James Nuss.)

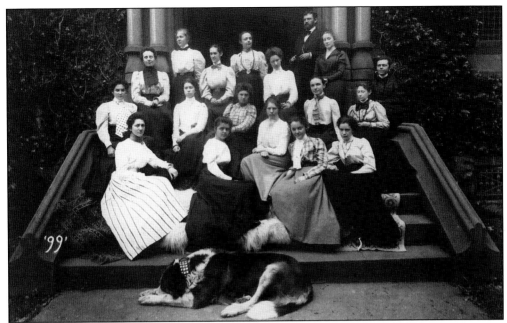

Linden Hall has always been committed to excellence in the education of young women, providing a rigorous and multifaceted college-preparatory experience. Each student is nurtured and inspired to reach her highest personal potential. The school values scholarly achievement, character development, cultural awareness, and physical wellness. Shown here is the graduating class of 1899. (Courtesy of Peggy Jones.)

A second girls' boarding school, Sunnyside College, was located on East Main Street near Linden Hall. Built by Rev. Julius Bechler, former headmaster of Linden Hall, it operated 1862–1878. Some 20 young ladies were taught subjects such as written and mental arithmetic, orthography, astronomy, physiology, elocution, mental and moral philosophy, and mineralogy. The cost of a 12-week session was $60. (Courtesy of Randy Miller.)

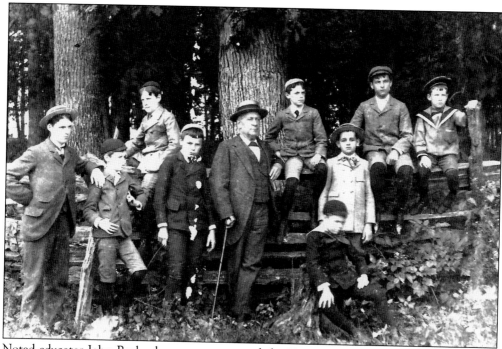

Noted educator John Beck, above center, opened the Young Gentlemen's Academy, below, in 1815. An underwhelming student in his youth, at age 15, he was sent to apprentice with a Lititz shoemaker. Upon completion of his apprenticeship, Beck was persuaded to tutor five local boys and soon after became master of the village school. Originally located in an abandoned blacksmith shop on Moravian Church Square, the school eventually closed and a new structure, the Lyceum Building, below, was built to serve the growing number of students. The academy moved to the Brothers House until 1865. In 1907, the Lyceum Building was taken down, and in 1908, the Moravian Home for Aged Women was erected. (Above, courtesy of Ronald Reedy; below, courtesy of James Nuss.)

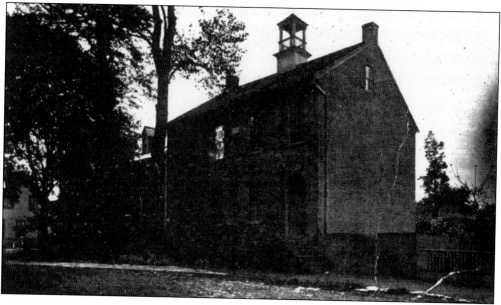

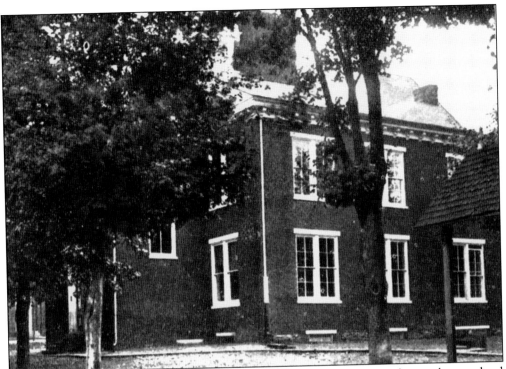

After the old 1870 school, seen above, at 20 South Cedar Street was taken down, a larger school was built on the same site, below, referred to by many as a "temple of education." It was regarded as one of the best schools in Pennsylvania and was renamed Lititz Public School. The cornerstone is dated 1916 but was not laid until 1917. (Above, courtesy of Ronald Reedy; below, courtesy of the Robert "Sketch" Mearig collection.)

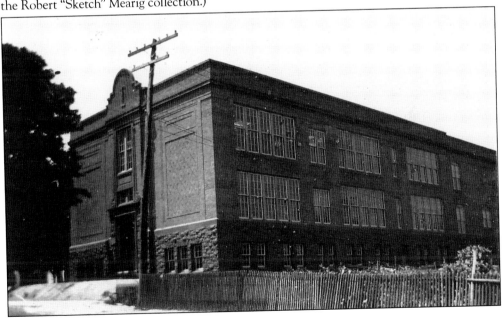

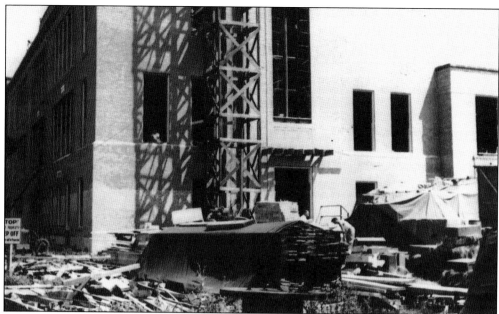

In 1935, local voters approved a plan to add an extension onto the Lititz Public School building, above, which was completed in 1940. During the dedication ceremony on March 26, 1940, residents were invited to inspect the school, which included a gymnasium that was rated the best in Lancaster County. In 1956, under a new consolidated Warwick Union School District, a new high school was built, below, and the Lititz Public School became known as Lititz Elementary. In 2006, this building was razed and a more modern elementary school was erected. (Courtesy of Ronald Reedy.)

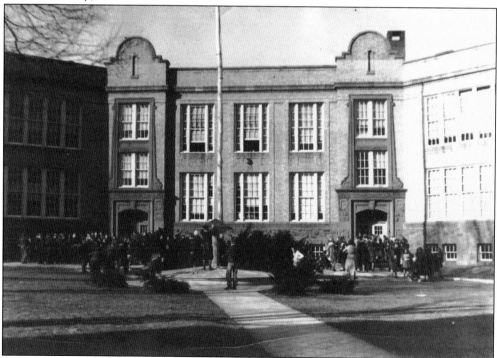

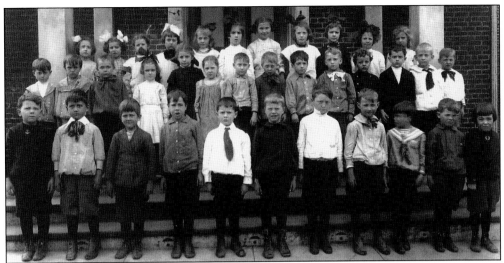

Children from the Lititz Public School's graduating class of 1913 stand for their class photograph. Shown are, from left to right, (first row) Charles Landis, John Martin, Charles Weidman, Harry Miller, Lloyd Hoffman, John Fasthnoch, Roy Leisy, unknown, James Howard, George Spickler, and William Miller; (second row) Arthur Rettew, Harry Runk, Raymond Reedy, Helen Keller, Silvia Pfautz, Mary Madilem, John Coldren, Robert Bopp, George Fleishnan, Howard Gingrich, Roger Loercher, Charles Hacker, Ralph Smith, and Clarence Keller; (third row) Helen Longenecker, Esther Getz, Marvel Rollman, Verna Druckermiller, Sarah Fry, Anna Young, Ada Necther, Laura Rudy, Viola Roth, Helen Bear, and Anna Stormfletz. (Courtesy of Ronald Reedy.)

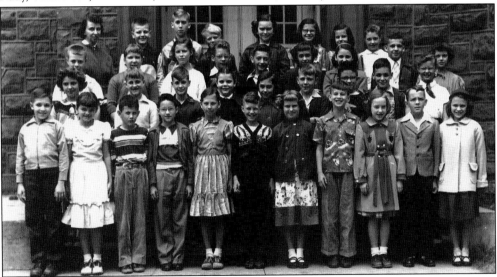

The 1952 graduating class of Lititz Public School is pictured with teacher Hazel Garner. Seen are, from left to right, (first row) Kenneth Kline, Sandra Witmer, Terry Eckert, Glenn Zartman, Patsy Adair, Randy Kling, Polly Garber, Jere Buchter, Judy Markert, Fred Garner, and Linda Pfautz; (second row) Barbara Yeagley, Kenneth Ruth, James Eckman, Jane Krushinski, Kay Burkholder, Ned Partridge, Rodney Hornberger, John Doster, and Debbie Lebo; (third row) Joseph Quinn, Sheila Mowery, MaryAnn Gorton, Edward Reese, Larry Gassert, Dawn Davidson, Bebe Kreider, John Badorf, and Barbara Kofroth; (fourth row) Fred Ruebman, Paul Herr, Frank Grube, Kathleen Longenecker, Mildred Habecker, Martha Habecker, and Joyce Ditzler. (Courtesy of Bernice Hendricks.)

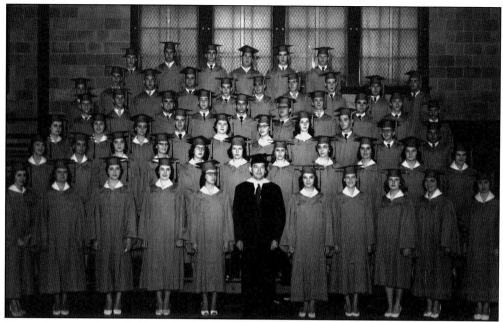

Pictured above is Lititz Public School's graduating class of 1956, the last class to graduate before the school changed to the Lititz Elementary School. (Courtesy of Bernice Hendricks.)

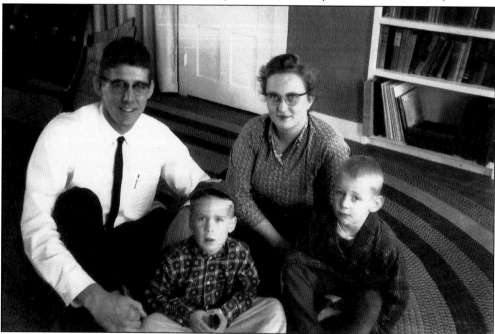

Lititz High School 1949 graduate Donald Kreider, here with his wife, Mary Ellen, and two of his three sons, Paul, left, and John, right, earned his doctorate in mathematical logic from Massachusetts Institute of Technology (MIT), where he was awarded the Goodwin Medal. He received one of the first grants in the Calculus Initiative launched by the National Science Foundation, served as president of the Mathematical Association of America in 1993, and authored several books. (Courtesy of Bernice Hendricks.)

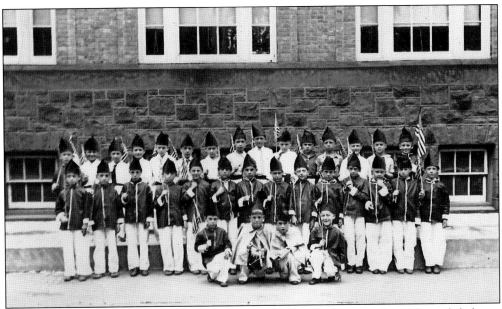

First- and second-grade boys stand at attention in their perfectly tailored uniforms while being photographed for the Lititz Public School's Spring Festival in May 1937. The fife player and drummer were adorned in sparkling gold capes. (Courtesy of Claire dePerrot.)

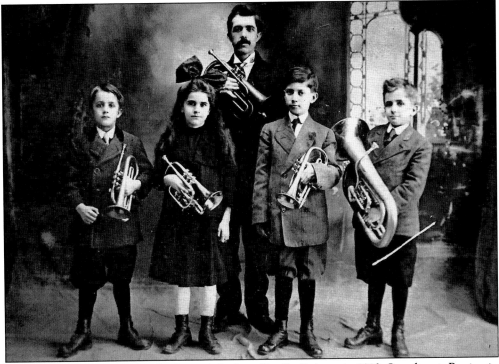

They were a musical family who formed the Lutz Family Quintet in 1913. Standing is Benjamin Fry (Benny) Lutz, patriarch of the group, and from left to right, his son Benjamin; daughter, Ruth; nephew Winfield Wilson, and son John. After Ruth's death in 1918, the family later reorganized under the name the Lutz Family Band. (Courtesy of the Robert "Sketch" Mearig collection.)

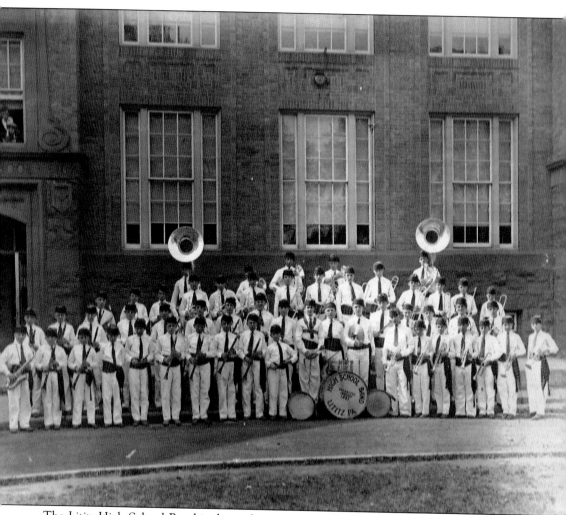

The Lititz High School Band is shown here in its first year, 1927. Seen are, from left to right, (first row) Robert Kreider, Monroe Wike, Rah Zartman, Rick Neidermyer, Rick McCloud, Clarence Newcomer, Paul McCloud, Paul Minnick, Robert Myers, Williard Stoner Drams, Hubert Kauffman, Wilbur Gamon, Charles Reidenbach, Ford Gochenauer, Carl Helman, Woodie Neidermyer, and William Gibson; (third row) Albert Steininger, John Hertz, Robert Lutz, Ray Runk, William Getz, William Stover, Charles Pfautz, Theo Huber, Lem Dussinger, George Kechn, Robert Pfautz, Hen Lutz, Lester Steffy, and Rich Rader; (fourth row) Mahlon Fry, Theo Herr, Walter Eiker, Howard Burkhart, and Charles Wagaman. Included in the second row are Galen Mohler, Herbert Longenecker, Victor Getz, Vic Pfautz, Horace Keller, M. C. Demmy (conductor), Donald May, Lloyd Hertzler, Charles Wever, Henry Sturgis, Clair Weber, and David Miller. (Courtesy of the Robert "Sketch" Mearig collection.)

The Lititz Men's Chorus met regularly in 1927. Seen here are, from left to right, (first row) Dr. Harry Wertsch, Sol Strohm, ? Helman, Ralph Weir, Ted Stauffer, Jerry Hertzler, Tom Maharg, Mac McCloud, Lloyd Hertzler, and C. Dussinger; (second row) Victor Wagner, ? Dengler, ? Baker, Jim Seaber, Harry Workman, Jerry Stark, Tom Dussinger, Harry Gonder, ? Weaver, Lester Sesseman, Roy Myers, ? Kiehl, and Minerva Haines, pianist; (third row) Emory Wagner, ? Miller, Harry Gingrich, ? Klaus, M. Huber, ? Lausch, G. Huber, Irvin Smith, ? Bingeman, and Klaus Kratzert. (Courtesy of Peggy Jones.)

The YMCA was located on the second floor of the Doster General Merchandise Store at 48 East Main Street. Above is the YMCA Chorus. Seen here are, from left to right, (first row) Tom Dussinger, Mr. Bailey, and Ott Pfautz; (second row) Henry Niess, Dr. Mahlon Yoder, James Seaber, Mr. Fry, John Pfautz, John Weaver, William Fassnacht, Daniel Weidman, Charles Dussinger, William Zellers, Robert Hackman, David Shenk, and Hiram Reedy (director). (Courtesy of Ronald Reedy.)

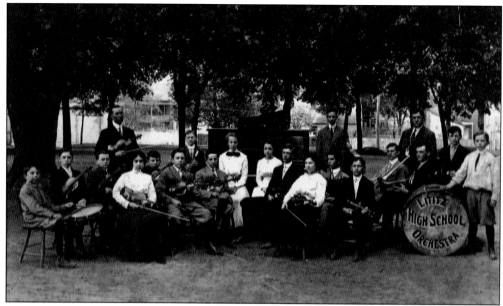

The Lititz High School Orchestra is pictured in Lititz Springs Park around 1910. Participants include Roy Hassler, Ernest Hagan, Margarite Long, Victor Wagner, ? Weitzel, James Carper, Ernest Baker, Ethel Masser, Viola Witmyer, Ray Shutt, Myrtle Hoffman Rader, Kenneth Witmyer, Earl Grosh, Emerson Groff, Paul Enck, principal A. S. Longenecker, Christ Lehman, and Paul Kreider. Conductor Paul E. Beck is standing at left, with the violin. (Courtesy of Ronald Reedy.)

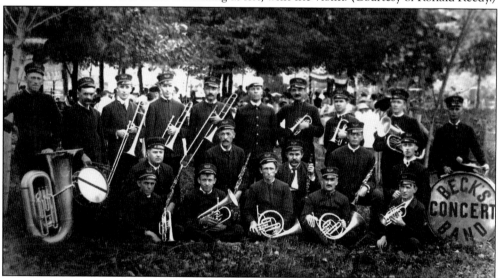

From 1895 to 1915, Prof. Paul E. Beck, sixth from left, standing, son of Abraham R. Beck and grandson of John Beck, both Lititz schoolmasters, taught music and art in the public schools in Lititz, Ephrata, Manheim, and Mount Joy. He also organized and conducted Beck's Concert Band. Pictured in this 1915 photograph are the band members. From left to right are (first row) Harry Pfautz, Paris Neidermyer, Adolph Uhlig, unidentified, and Fred Uhlig; (second row) Mr. Kline, Harry Myers, Addison Nagle, Joseph Mohn, and Louis Huebener; (third row) William Uhlig, John Fry, Wilson Enck, Charles Hackman, William Neidermyer, Prof. Paul E. Beck, Jerry Buchter, Harry Keppel, Henry Hackman, and Grand Birkenbine. (Courtesy of Ronald Reedy.)

Four

WORLDLINESS

It was the goal of the Moravian founders to live in a community where spiritual needs were the focus, not worldly concerns. To this end, the Moravian congregation created an administrative committee, the Aufseher Collegium, which supervised all aspects of life in the new town. Each resident, who had to be Moravian to live within the town's boundaries, was required to sign the Town Regulations of 1759, agreeing to abide by its terms, including "No dancing matches, taverning (except for the necessary entertaining of strangers and travelers), beer-tappings, feasting at weddings, christenings or burials, common sports and pastimes, nor the playing of the children in the streets, shall be so much as heard of amongst the inhabitants. They that have inclinations that way cannot live at Lititz." Even marriages were included: "No marriage shall be contracted or made without the privity and appropriation of the Elders and of the congregation and choirs. Nor shall anyone attempt to promote or make secret matches."

The congregation was allowed to conduct businesses, as granted by a charter of the crown; included were: a general store, a tavern, a pharmacy (the first in Lancaster County), a potash factory, a gristmill and sawmill, and several farms. All of these were required to make an annual report to the Aufseher Collegium. There were also many individually conducted businesses that had been approved by the congregation.

In 1855, the charter changed, and Lititz opened its doors to new businesses. The lease system, whereby each resident had been leasing the land on which his home was built from the church, was ended, and the lots were sold to the homeowners. Businesses sprang up, new homes were being built, and people of all faiths were being welcomed.

Worldliness had come to Lititz, changing it forever.

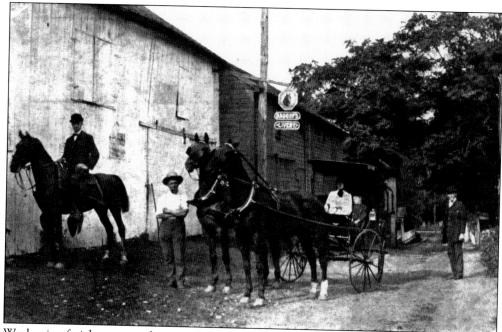

Wachovian freight wagons that traveled from Winston Salem, North Carolina, to Bethlehem, Pennsylvania, in the latter part of the 1860s would routinely stop at the livery stables in Lititz to change their teams of horses. The stables above were located in a driveway beside an open-air farmers market where the Farmers Bank is located today. (Courtesy of Randy Miller.)

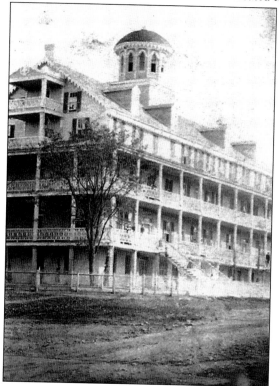

Originally, the Wabank House stood along the banks of the Conestoga River, southwest of Lancaster. In 1863, Samuel Lichtenthaeler purchased the four-story building, had it dismantled, and then brought to Lititz. Operated by the Lititz Springs Hotel management, the old building adjoined the hotel to the south. On July 21, 1973, it burned to the ground. (Courtesy of Ronald Reedy.)

In the distance, to the left, is the Park House. During the 1880s, it was a boardinghouse and restaurant run by John C. Crall, who dubbed it the Park Hotel. It was renamed the Park House in the 1890s by the next owner, Dr. James C. Brobst, a local druggist. By 1895, it was leased to Levi Hacker, who ran it as a boardinghouse and saloon. C. N. Mohler was proprietor from 1898 until around 1900, when M. L. Dellinger stepped in to run the establishment. Mysteriously by 1916, nothing more is told of this grand old house until 1941, when the building and land was sold to Elam Habecker and Henry J. Snavely, then demolished in 1957. (Courtesy of Randy Miller.)

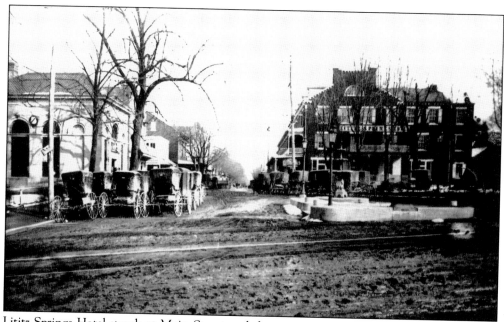

Lititz Springs Hotel stands at Main Street and the town square in 1908, above, the only one of the early congregational businesses still doing business at its original site, making it one of the oldest continuously operating inns in the United States. Formerly known as Zum Anker (Anchor Inn), it was built in 1764 and owned and operated by the Lititz Moravian congregation until 1854. It changed hands—and names—several times and today is known as the General Sutter Inn, a nod to the town's most famous citizen. During World War II, the inn felt the impact; the inn's rooms were all but vacant (below). Today the General Sutter Inn is a highly regarded establishment, updated with every modern amenity and includes the 1764 Restaurant, offering the ultimate fine dining experience. (Courtesy of Randy Miller.)

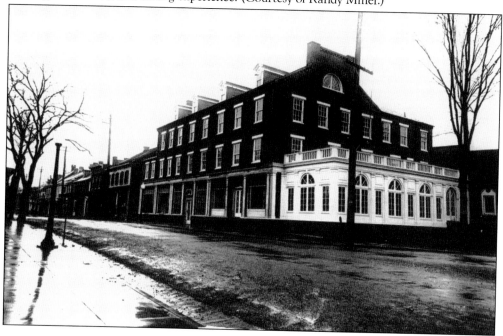

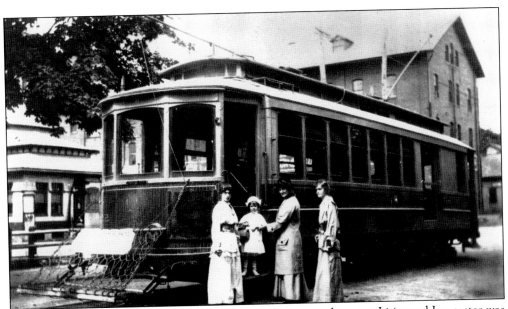

A meeting of citizens to consider establishing trolley service between Lititz and Lancaster was held on February 6, 1890. Trolley tracks were completed as far as Kissel Hill by April 30, 1895, when the first trolley with passengers left Lancaster's Penn Square Station at 8:00 a.m.; cars ran to the southern borough limit. On July 21, 1899, the trolleys ran a new route that ended at the entrance of Lititz Springs Park, above, the final terminus of the Conestoga Traction Company in Lititz. This allowed Lancaster riders to arrive in Lititz every hour on the hour, 5:00 a.m. until 11:00 p.m. Lititz locals could visit Lancaster every hour on the hour, 7:00 a.m. until 10:00 p.m. Conestoga Transit Company began replacing the trolley lines with buses in 1932, seen below. On Monday, February 21, 1938, the last passenger-carrying trolley left Lititz. (Above, courtesy of Randy Miller; below, courtesy of the Robert "Sketch" Mearig collection.)

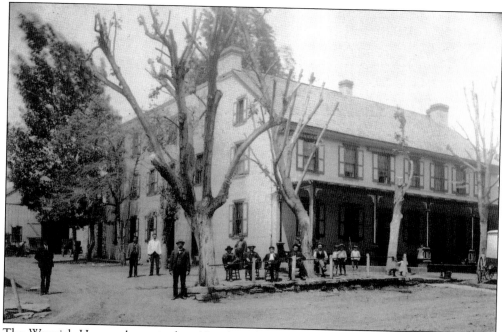

The Warwick House, above, is the oldest hostelry in Lancaster County, established in 1809. It was located along the north–south route of what is now known as Broad Street and offered a convenient and inexpensive stay. After changing ownership countless times, John S. Badorf purchased the property and established its fine reputation. In 1992, the newest owner changed the name to the Toy Soldier, which functions today as a bar, restaurant, and apartment building. In the image below, the year is 1896, a period during which the Warwick House brought in guests that traveled along the trading route that led to Lancaster. Next to the Warwick House is the "lawn area," a flowery oasis where the inn's guests enjoyed the colorful plantings, a fountain, and a small pavilion. (Above, courtesy of Randy Miller; below, courtesy of the Robert "Sketch" Mearig collection.)

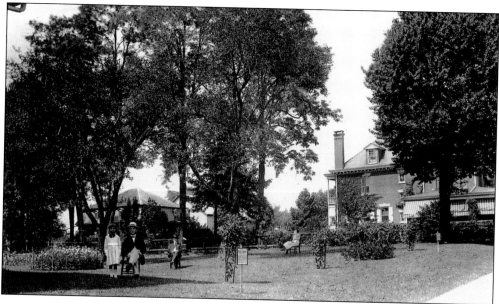

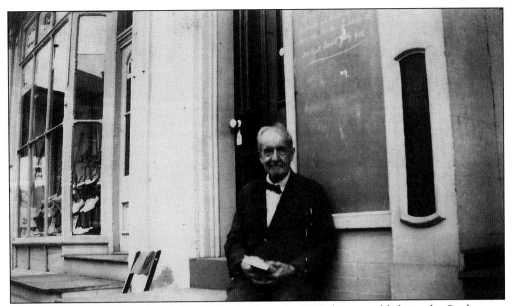

Sparring began in 1881 when John G. Zook, above in 1938, began publishing the *Sunbeam*, a monthly magazine and forerunner of the *Weekly Express* newspaper, later renamed *Lititz Express*. Editor John Buch, however, had been issuing a weekly newspaper since 1877, the *Lititz Record*. Buch ran his paper until 1917; Zook ran his until 1937, when the two papers merged, creating the *Lititz Record-Express*. Zook published his paper at 22 East Main Street, below, where he also sold bicycles. The business was later relocated to a small building in the rear of 22 East Main Street, where it flourished until October 2006, when its production activities were relocated to Ephrata. (Above, courtesy of the Robert "Sketch" Mearig collection; below, courtesy of Randy Miller.)

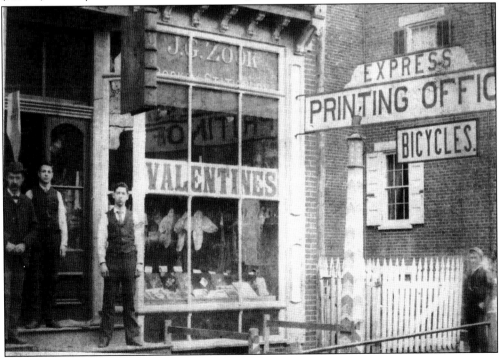

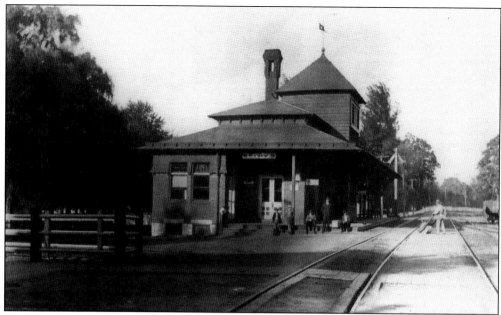

The Reading and Columbia Rail Road passenger depot and express station in Lititz, above, opened to the public in 1884 on land leased from the Lititz Moravian Church. On October 28, 1952, Democratic candidate Adlai Stevenson, below, rode on the last Reading Railroad passenger train that would ever travel through Lititz. The station stood until 1957, when it was demolished to make way for a more convenient entrance to the park. A replica of the lovely 1884 depot was built and dedicated in 1999, which now serves as the Lititz Welcome Center. (Above, courtesy of Randy Miller; below, courtesy of Ronald Reedy.)

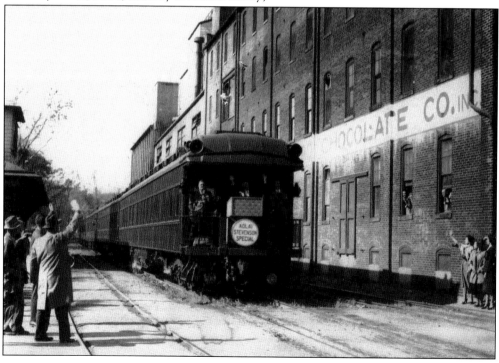

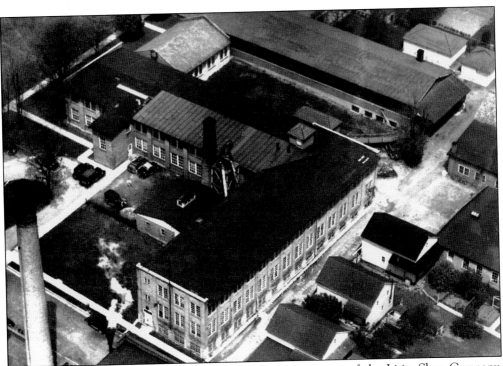

The Eby Shoe Company began in 1904 with the organization of the Lititz Shoe Company, located in the former Kendig Manufacturing Company building on Kleine Street. That same year, the Lititz Shoe Company and the Eby Shoe Company merged and renovated an old planning mill, above, that had been owned by Seaber and Grube. The new company installed machinery for the manufacture of 1,000 pairs of children's shoes per day. The inside of the factory is shown below with several staff members. Included are Jake Keener, Woodie Furlow, Paul Schmuck, Edward Walters, Stanley Diehm, Alvin Long, and Monroe Nelson. (Courtesy of the Robert "Sketch" Mearig collection.)

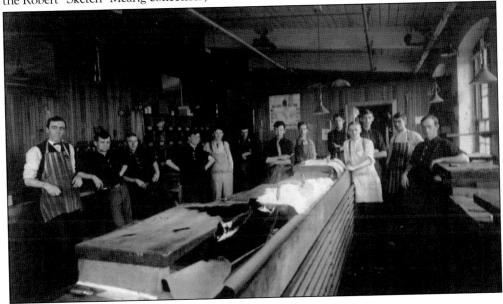

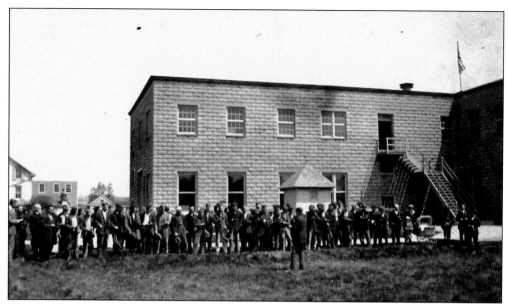

The J. M. Mast Manufacturing Company, above, begun on Water Street in 1902, merged with Animal Trap Company in 1905, which kept that name and built a new factory on Locust Street. This company had William Hooker's 1894 patent that revolutionized the mousetrap; the company soon became the largest manufacturer of animal traps in the world. Oneida Community Limited of New York bought a controlling interest and in 1910 bought it out entirely, changing the name to Oneida Community Trap Company, below. In 1924, the business was sold to three employees, and it became known as Animal Trap Company of America. The name was changed to Woodstream Corporation in 1966; it is best known for the production of Victor mousetraps. (Above, courtesy of Randy Miller; below, courtesy of Ronald Reedy.)

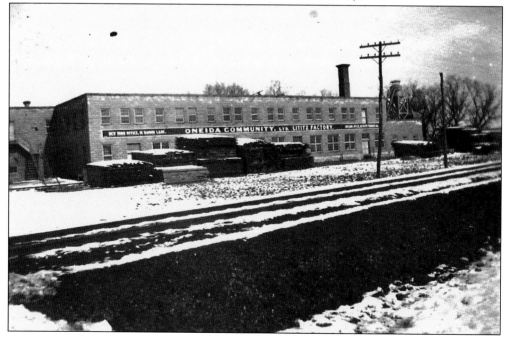

The few industrial plants in Lititz during most of the 1800s supplied only local customers. In 1898, the Keystone Underwear Mill located on West Main Street was established and industry in Lititz began to flourish. Organized by Samuel B. Erb, Adam Long, and Israel G. Erb, the company was incorporated in 1905. Business flourished, and their products were soon being sent to locations throughout the United States and eventually, overseas. (Courtesy of the Robert "Sketch" Mearig collection.)

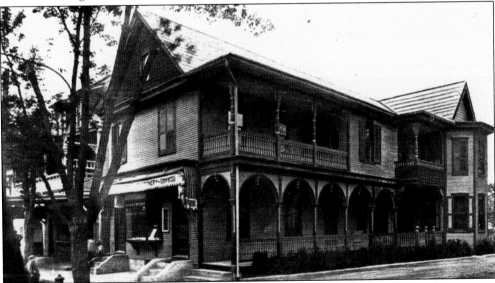

In 1909, Hiram Holtzhouse purchased property at 23 North Broad Street and by the spring of 1910, opened Holtzhouse's Confectionery. On opening day, guests found a vase of sweet peas on every table and Hiram's three daughters, Ethel, Hannah, and Marian, serving as waitresses. By the mid-1930s, after Hiram's death, the business was sold and became known as Glassmyer's Restaurant. (Courtesy of James Nuss.)

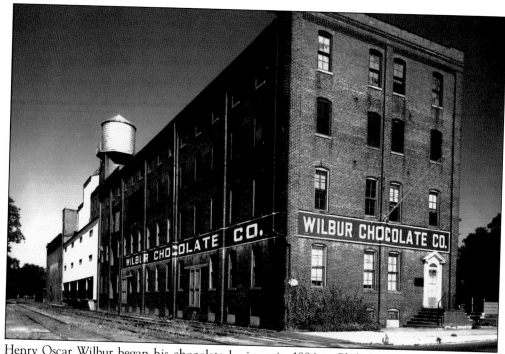

Henry Oscar Wilbur began his chocolate business in 1884 in Philadelphia, incorporating as H. O. Wilbur and Sons in January 1909. Mergers and sales changed the company's name several times and due to growth, moved the company's factories from Philadelphia and Newark to Lititz. Wilbur Chocolate Company, above, was sold in 1992 to Cargill, one of the largest private companies in the United States, but retained the Wilbur name. The company's manufacturing plants currently manufacture products that are shipped to confectioners, dairies, bakers, and candy makers across the nation. In addition, a variety of premium consumer items are purchased through the Wilbur Candy Americana store and its mail-order department. (Above, courtesy of the Robert "Sketch" Mearig collection; below, courtesy of Ronald Reedy.)

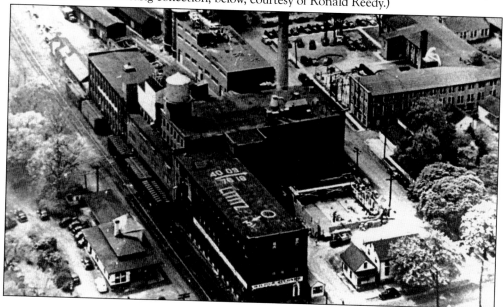

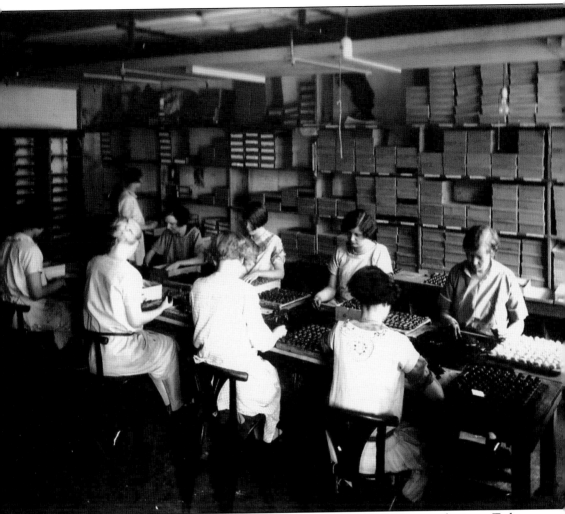

The 1923 photograph above shows Wilbur candy makers hand dipping confections. Today guests can watch as candy makers still hand dip and hand mold chocolate delights. Visitors to Lititz are led to Wilbur Chocolate by following the aroma of warm chocolate that permeates the air throughout town. Inside guests find displays of chocolate memorabilia, a re-creation of an early-19th-century candy kitchen, a working candy kitchen on view, and a store that has chocolate items available only in Lititz. Guests are treated to a free Wilbur Bud and learn that the famous creamy Wilbur Bud was created 14 years before the similarly shaped Hershey's Kiss. (Courtesy of Wilbur Chocolate Company.)

Recently a dozen diaries written by a former Lititz resident of the early 1900s surfaced at an auction many miles from Lititz. The author was John J. Heiserman, left, who lived with his wife, Anna, and his daughter, Mary, also pictured at left, at 320 East Main Street. Entries record events such as Easter morning, factory sirens and church bells ringing in the "new year, 1922," and Dr. J. L. Hertz charging $1 per vaccination for smallpox. Another entry on December 13, 1920, told of a successful trip to Pfautz Brothers store at 28 East Main Street. Below is a flashlight photograph of Pfautz Brothers store taken on May 14, 1913, of the remodeled and enlarged department store on opening night. (Courtesy of the Robert "Sketch" Mearig collection.)

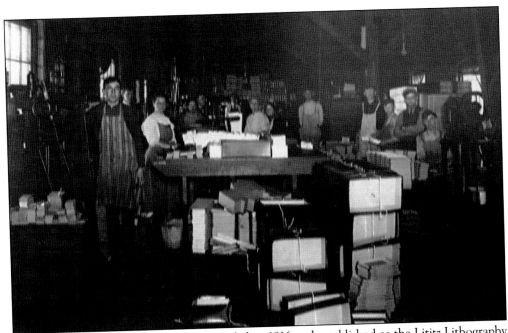

Simplex Paper Box Corporation was founded in 1916 and established as the Lititz Lithography Company, located on Water Street. The company began selling packaging material as well as printing in 1922 and was renamed Lititz Paper Box and Printing Company. In 1930, the company applied for patents and once again renamed itself Simplex Paper Box Corporation in reference to the simple box it produced. In 1935, the company relocated to Lancaster until 1970, when it was sold and briefly shut down. Reorganization took place in 1971, which required relocation to new quarters in Columbia, where it thrived until 1991; Simplex Paper Box Corporation's final move to Hellam was made that year. These photographs show the interior of the company while functioning in its Lititz location. (Courtesy of the Robert "Sketch" Mearig collection.)

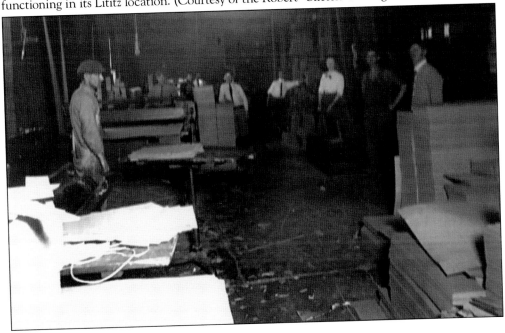

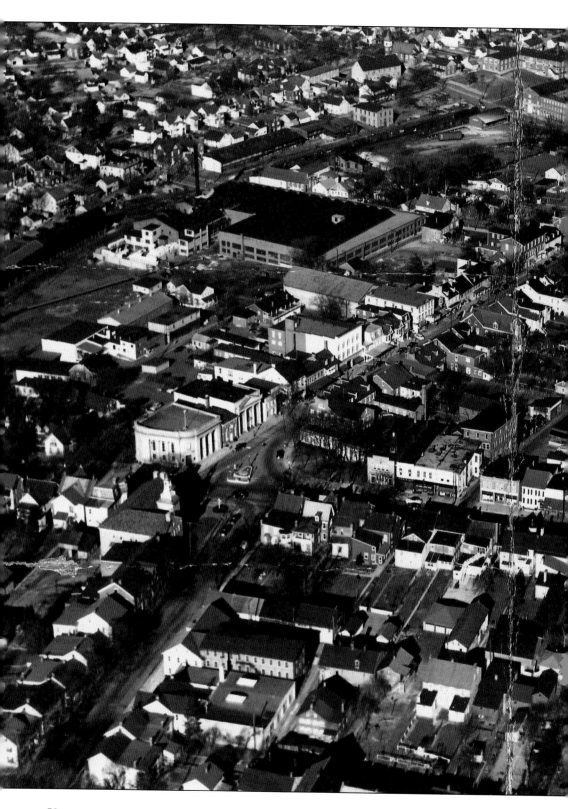

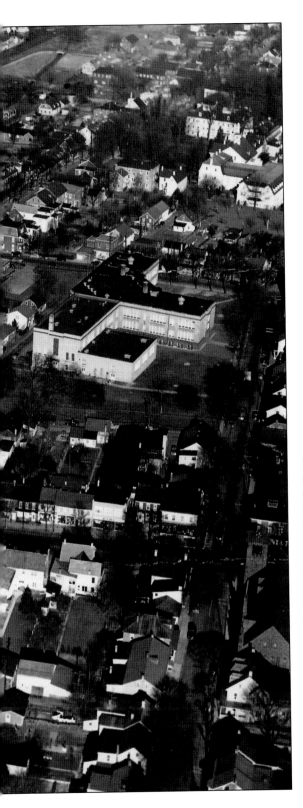

By the 1940s, Lititz had grown extensively and new businesses, including some larger companies, had made their way to the small town, as seen here. Animal Trap Company of America, Wilbur Suchard Chocolate Company, Morgan Paper Company, knitting and underwear mills, garment factories, shoe factories, and furniture factories provided employment during the Great Depression days and World War II. The trolleys of Lititz had come and gone, and although not known at the time of this photograph, just a few years later the pharmaceutical company, Warner Lambert, would come to town and provide hundreds of jobs for local residents. Today Lititz is a thriving community of just over 9,000 residents and is participating in Venture Lititz, an organization dedicated to strengthening the economic vitality and quality of life in downtown Lititz. (Courtesy of Ronald Reedy.)

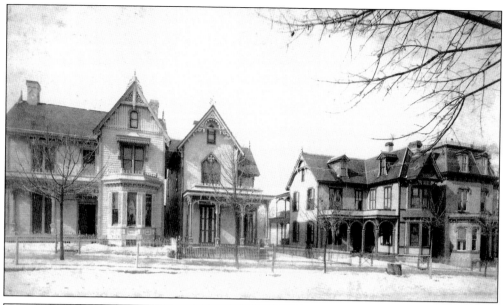

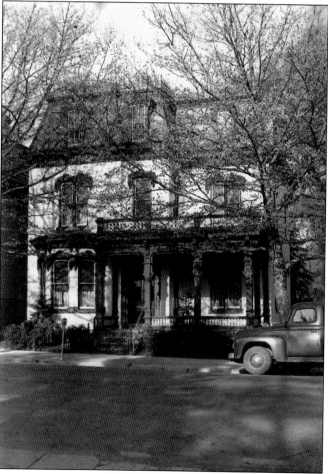

Only the wealthy could afford these beautiful Victorian homes, called Cottage Row, above, that sat on North Broad Street to the west of Lititz Springs Park. Porches were large with turned posts and decorative railings, gable trim, and corbels. Although lovely to see, as the years passed, they began to fall into disrepair, and the cost to repair or renovate was prohibitive. In 1940, the first of the four homes, the Garber home on North Broad Street, left, was demolished. In 1956, the remaining three homes were taken down. (Courtesy of the Robert "Sketch" Mearig collection.)

The Lititz Post Office, far left, 68 East Main Street, was once home to Andrew Albright, a respected gunsmith who created Pennsylvania rifles. The Pennsylvania rifle became the preferred weapon among settlers moving over the Appalachian Mountains. It was so popular on the frontier that it became known as the Kentucky rifle. It is noted in history books that Pennsylvania produced more of these rifles than all other colonies combined. (Courtesy of James Nuss.)

The stunning brick building at 109 North Broad Street began as Bob Enck's Garage, later changing to the Kaiser-Frazier Garage. After several incarnations and renovations, the building is now the home of the Lititz American Legion, Garden Spot Post 56, the first Legion Post in Lancaster County. It was organized in 1919 and chartered in 1920. (Courtesy of the Robert "Sketch" Mearig collection.)

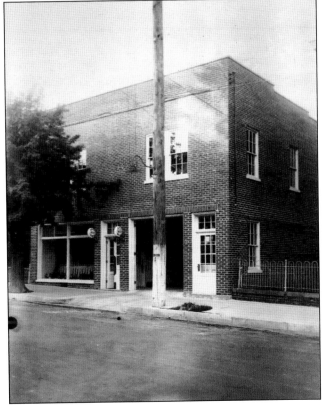

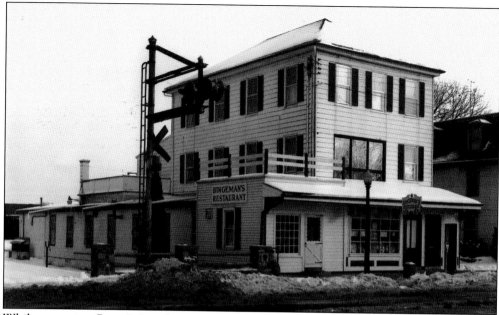

While operating Rosey's Lunchwagon, Arthur "Rosey" Rosenberg purchased and operated Weaver's Restaurant for 15 years. Rosenberg then sold the eatery, at which point it became Bingeman's Restaurant and remained in business for another 25 years. "Bingey's" was the place to be to learn about all the news in town; it was in a corner seat in Bingey's that the editor of the town's newspaper would write his best editorials. (Courtesy of Marion Weaver.)

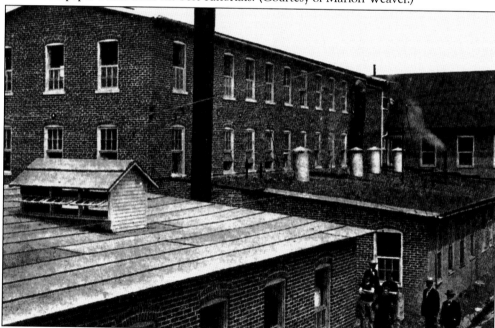

It was the Keystone Underwear Mills, established in 1898, that gave Lititz businessmen an eye to the future of the town's industrial future. Organized by Samuel B. Erb, Adam Long, and Israel G. Erb, it was incorporated in 1905. The directors then were Israel, Long, G. Gray, William Diehm, Henry H. Snavely, and John L. Wentworth. (Courtesy of Ronald Reedy.)

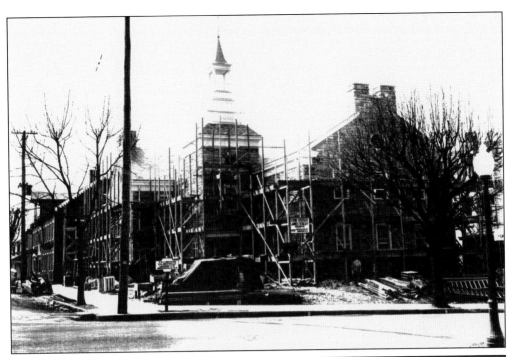

This lovely building, right, at 2 North Broad Street sits where Cottage Row once stood. Lititz residents fought to save the old Victorian homes but were not successful; they were taken down in 1956 to make room for a gasoline station. Locals, worried that the integrity of the historic aspect of town would be lost, fought against the gasoline company and prevailed. Later an insurance company built an office on the site, above, with an exterior in keeping with the town's historical architecture. That company is known today as Lititz Mutual Insurance Company. (Courtesy of the Robert "Sketch" Mearig collection.)

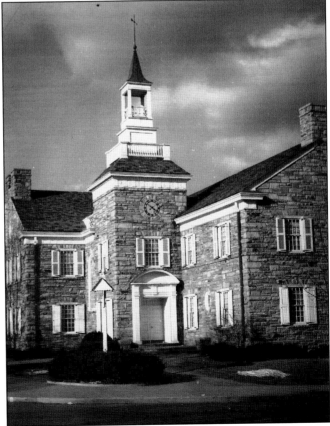

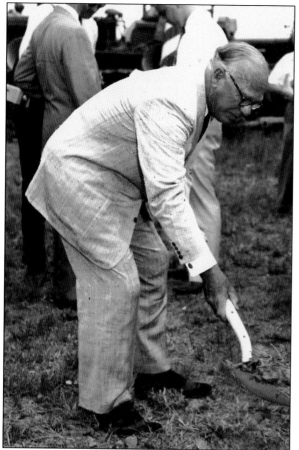

Elmer Holmes Bobst took the first shovelful of earth on August 4, 1955, at the groundbreaking ceremony of the new 100-acre Warner-Lambert plant. The Lititz native had evolved into a multimillionaire in the pharmaceutical industry and at 61 had been president of the Hoffmann-LaRoche's United States office until, in 1945, he accepted the presidency of William R. Warner and Company. He changed the company's name to Warner-Hudnut in 1950, followed five years later with a merger between his company and Lambert Pharmacal; former governor Alfred Driscoll was named as president of the new company. Pfizer Global Manufacturing and Warner-Lambert merged on February 7, 2000. After a buyout on December 22, 2006, the site became Johnson and Johnson, a subsidiary of McNeil Pharmaceuticals and is a global supplier of consumer health care products. (Left, courtesy of the Robert "Sketch" Mearig collection; below, courtesy of Lititz Historical Foundation.)

Five

WAR

Every town in America, small or large, has felt the sting of war, but it is the small towns that pay the heaviest tolls.

The early Moravians were pacifists, which meant that they could not bear arms; their church taught them to be willing to die, but not to kill for their beliefs. Lititz Moravian Church was drawn into the Revolutionary War, however, when in 1777 Gen. George Washington commandeered the Brothers House so it could be used as a military hospital. Over 1,000 soldiers arrived, but within weeks over 100 of the troops died of "camp fever," what is known now as typhoid. The remains of those young soldiers are buried in a plot in the 500 block of East Main Street. The stubborn disease also took the lives of several of the doctors and of the townspeople.

In the ensuing years, as Lititz opened to outsiders, pacifism faded, and Lititz residents, Moravian or not, proudly left to fight in war after war. On the home front, Lititz families showed their patriotic pride. During World War II, they tended victory gardens, rationed food and fuel, and volunteered as plane spotters. Local Girl Scouts and Boy Scouts collected scraps to give to factories. Women who had not been in the workforce followed Rosie the Riveter's encouragement and secured jobs to help make war-related products such as ammunition at the Animal Trap Company. Others enlisted in the women's divisions of the various armed forces.

William Young, editor of the *Lititz Record-Express*, filled the pages of the newspaper with news about Lititz men and women serving abroad while locals met at Bingey's, the restaurant on Broad Street where everyone "in the know" gathered to talk about the war.

Lititz is extremely proud of its countless sons and daughters who have served and are serving in the United States military; their legacy is freedom, not just for a small town in Pennsylvania but for the United States of America.

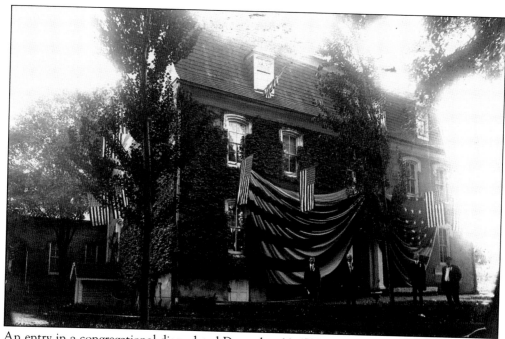

An entry in a congregational diary dated December 14, 1777, states that by the orders of Gen. George Washington, 250 sick and wounded soldiers were to be quartered in the Brothers House in Lititz. Soldiers arrived less than a week later, attended to by two doctors sent by Washington. Within just days, camp fever, more commonly known as typhus, broke out, bringing the doctors to their knees and killing not only the assistant pastor but five Moravians who had volunteered as aides. A highly trained physician, Dr. William Brown was sent to the Brothers House a month later. While stationed there, Dr. Brown compiled America's first pharmacopoeia (medical encyclopedia) in the building shown below, which was located behind the Brothers House. The pharmacopoeia was published in Philadelphia in 1778. The structure, dubbed the Regenna's House, was torn down in 1934. (Courtesy of the Robert "Sketch" Mearig collection.)

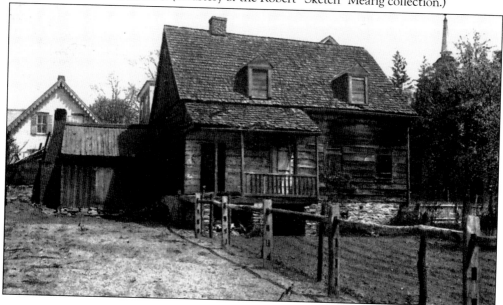

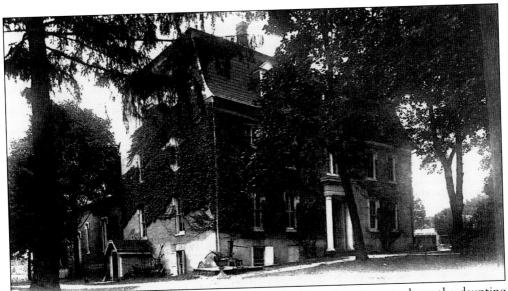

After the hospital closed on September 16, 1778, the Moravian sisters took on the daunting task of thoroughly cleaning the Brothers House. Notes in a diary tell of what the sisters found: "Filth beyond comprehension, blood on the floors, almost every window cracked or broken, walls scratched and marked with dirty fingerprints." The Moravian brothers stepped in to assist, finishing by meticulously cleaning and repainting every wall in the building. (Courtesy of James Nuss.)

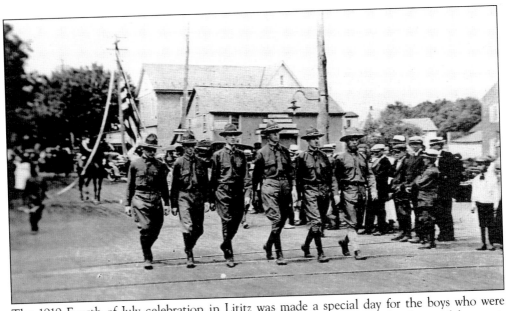

The 1919 Fourth of July celebration in Lititz was made a special day for the boys who were serving their country. Every branch of the service was acknowledged by the theme of the event, "Welcome Home to the Boys." Homes throughout town were decorated, and the town square was adorned. All the local soldiers and sailors who made it home for the celebration paraded in the afternoon. (Courtesy of the Robert "Sketch" Mearig collection.)

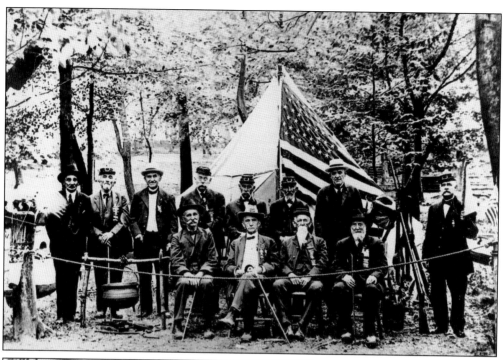

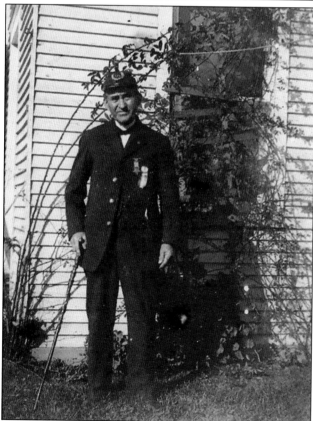

The final Memorial Day encampment in Lititz Springs Park of the members of Stevens Post Number 517 of the Grand Army of the Republic took place on May 31, 1920, as shown above. Seen are, from left to right, (first row) Edwin Enck, John A. Carpenter, Edwin Sturgis, and William Smith; (second row) George Hackman, Urias Adams, John C. Crall, Hiram Demmy, Allen Hacker, John Enck, Michael Bear, and William Mathers with the flag. Pvt. John C. Crall, Company K, 209th Infantry Regiment of Pennsylvania, left, enlisted on August 28, 1864. Crall fought in the last days of the Civil War at Petersburg, Virginia, and was discharged on May 31, 1865. He was the last surviving member of Stevens Post No. 517. (Courtesy of Ronald Reedy.)

The Army Air Force was organized in June 1941; by December 25, 1941, the first unit arrived at the DeRidder Army Air Base. While at the base, 35 men died in training accidents in and around the DeRidder Army Air Base and Gunner Range near Merryville, Louisiana. The first casualty from Lititz was S.Sgt. Richard L. Wentling, right, who was killed there when his army bomber crashed during routine training. (Courtesy of Robert Good.)

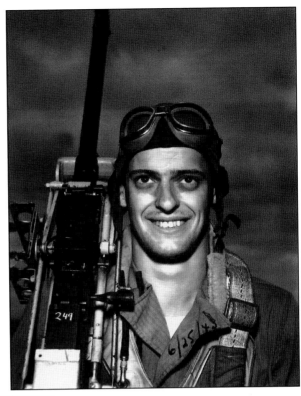

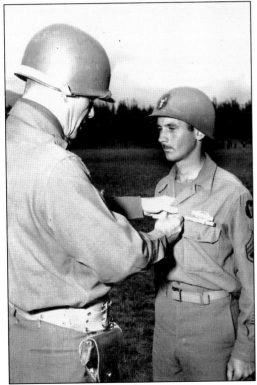

Maj. Gen. Charles L. Bolte awarded the Silver Star to S.Sgt. Gordon H. Yingst of Lititz for gallantry in action of the 5th Army Front, Company K, 133rd Infantry Regiment, 34th Division, 5th Army, Rivoli area, Italy, on May 23, 1945. The Silver Star is the nation's third-highest medal for valor and is given in recognition of extraordinary heroism. (Courtesy of the Robert "Sketch" Mearig collection.)

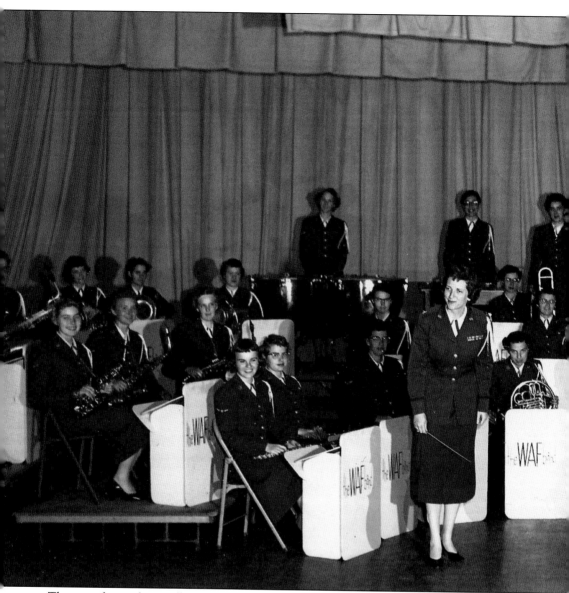

The very first military all-women band, the Women's Army Band, was organized in 1942 by Sgt. Mary Belle Nissly (conductor, center), the first girl drum major and student band director of Lititz High School. Nissly's accomplishments were many, including recognition as the first woman in military history to win a warrant officer bandleader appointment. In 1946, Nissly left the army and returned to service as a captain in the U.S. Air Force in 1951, when she created

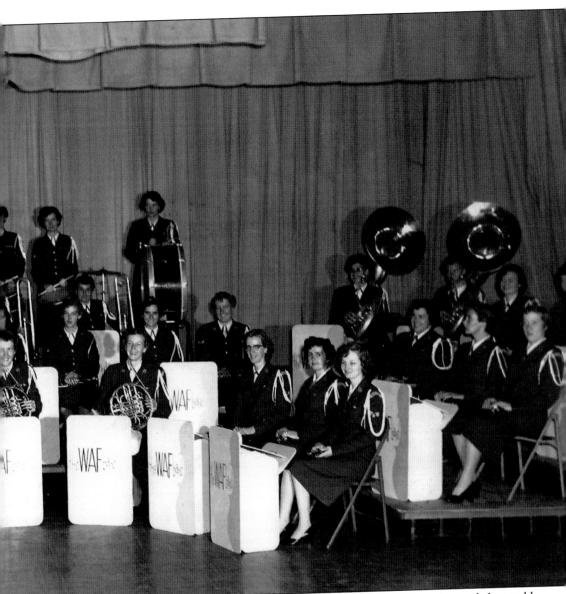

the U.S. Air Force Women's Air Force Band (WAF Band). The WAF Band toured the world for 10 years but was deactivated in October 1961. Nissly retired from the U.S. Air Force in 1968 and began a new career teaching music at the University of Arkansas at Little Rock. Mary Belle Nissly passed away on July 30, 1999. (Courtesy of the Robert "Sketch" Mearig collection.)

Pennsylvania senator Richard A. Snyder was born and raised in Lititz, growing up in the Werner House at 66 East Main Street. He attended Moravian College, then transferred to Franklin and Marshall College, graduating in 1931. After graduation, he followed in his mother's footsteps by becoming the Lititz correspondent for the Lancaster newspapers, eventually covering the political arena. While working for the newspaper, he pursued his law degree but, before he could take his bar exams, was called to serve in the military's Counter Intelligence Corps. Upon his return home, he secured his degree through Temple Law School in 1942 and began private practice in 1945. In 1962, Snyder was elected to the Pennsylvania Senate where he served for 22 years. Senator Snyder was also honored as a recipient of the William Penn Committee's Distinguished Pennsylvanian Award. (Courtesy of Peggy Jones.)

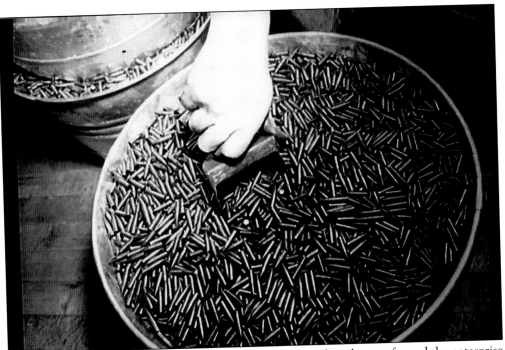

In 1940, the head of the Animal Trap Company, C. M. Woolworth, transformed the enterprise into a war machine. Army cots, coat hooks, fastening devices for airplane parts, fuse plugs, wire springs for parachutes, and bullet cores of several calibers were all manufactured in the Lititz plant. The company was presented with the E Award in 1943 for excellence in the production of war equipment. (Courtesy of Library of Congress.)

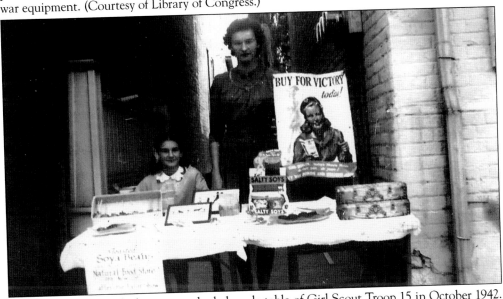

"Buy for Victory" reads the sign on the bake sale table of Girl Scout Troop 15 in October 1942. Troop Leader Barbara Slosser and Girl Scout Mary Margaret Smith sold homemade fudge and other goodies on Main Street beside Benner's store to support the troops. Although Girl Scout cookies were normally sold, due to shortages during the war, cookies were not available; instead, Girl Scout calendars were sold. (Courtesy of Claire dePerrot.)

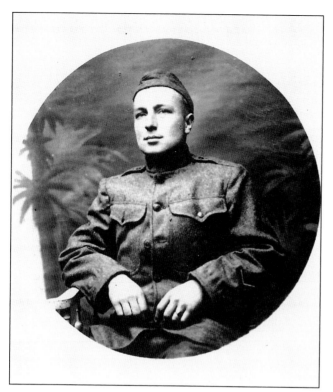

On August 10, 1918, Clair Rice, stationed "somewhere in France," scribbled a quick note to his cousin back in Lititz. "As for whipping the Huns, that is a sure thing—we WILL before we return. At present everything seems to be going our way. My hopes and prayers are that it will soon come to an end and we all have a speedy return to our loved ones." (Courtesy of Lititz Moravian Church.)

Paul Ira Ritz, right, served in the U.S. Navy during World War II. Back in Lititz, his father, an ex-serviceman, was employed as a candy coater in the chocolate factory and served two hours each week in Lititz as an airplane spotter in the observation post on a tower located between Lexington and Brunnerville, now occupied by the Middlecreek Reception Hall. (Courtesy of Lititz Moravian Church.)

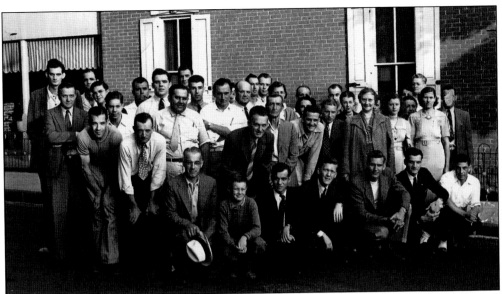

Monthly during World War II, the Lititz Service Association would gather in the kitchen of the local firehouse to pack a box for each Lititz man and woman who was in the service or leaving for the service. Items for the boxes were garnered from donations by local companies and individuals. By November 1942, there were approximately 300 Lititz residents serving their country. (Courtesy of the Robert "Sketch" Mearig collection.)

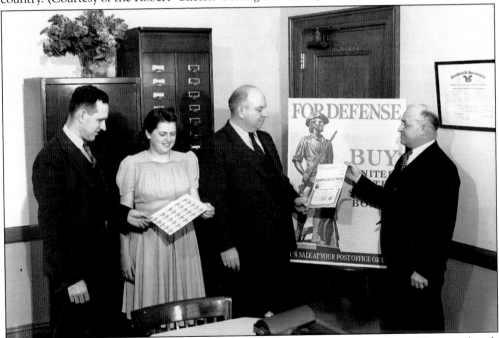

After the United States formally entered into the war in December 1941, Series E savings bonds became known as war bonds. Seen here in 1942 are, from left to right, Edward Bear, Vivian Ranck, Lititz burgess Victor Wagner, and postmaster Robert Pfautz bringing new war bonds to Lititz. Pfautz had three sons and one son-in-law in the service, as well as a daughter who worked in the United States War Department. (Courtesy of the Robert "Sketch" Mearig collection.)

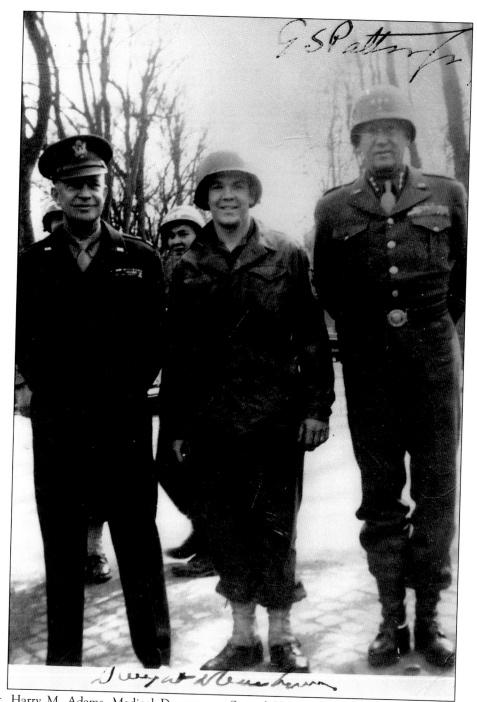

Sgt. Harry M. Adams, Medical Department Special Troops, Third U.S. Army, France, in 1944, spotted Gen. Dwight D. Eisenhower and asked to have his photograph taken with him. "Sure," the general replied. Eisenhower saw Gen. George S. Patton and called him to join in the photograph. After this photography session, Sergeant Adams received an autographed copy of the picture accompanied by a note sent by 1st Lt. Kay Summersby, Eisenhower's chauffeur, secretary, and alleged mistress. (Courtesy of Lititz Springs VFW Post 1463.)

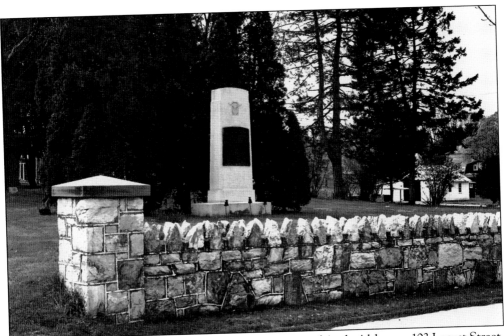

In 1932, while digging a cellar for a house on the property of Andy Althouse, 103 Locust Street, Morris Frederick discovered the bones of 110 Continental army soldiers. The remains were moved to the Revolutionary War memorial area, which was erected in 1928 on the farm of Frederick, who donated the land on East Main Street. (Courtesy of Lititz Historical Foundation.)

Jene and Claire dePerrot, like many patriotic citizens across the nation during World War II, tended to their vegetable victory garden. As shortages and rationing became harsh realities during the war, victory gardens sprang up in backyards and vacant lots in every town. As of 1943, victory gardens like the one lovingly tended by Jean and Claire, were producing 50 percent of all fresh vegetables consumed in the United States. (Courtesy of Claire dePerrot.)

Peggy (Snyder) Jones, is shown with brothers Robert Snyder, left, and Richard Snyder, right. Robert, taken prisoner in 1944, cheered up other prisoners by telling of the night, when working at the General Sutter Inn, he received a call requesting a room for Eleanor Roosevelt. Thinking it was a prank, he replied, "I'm sorry, I just gave the last room to Dolly Madison." He later discovered the call was legitimate. (Courtesy of Peggy Jones.)

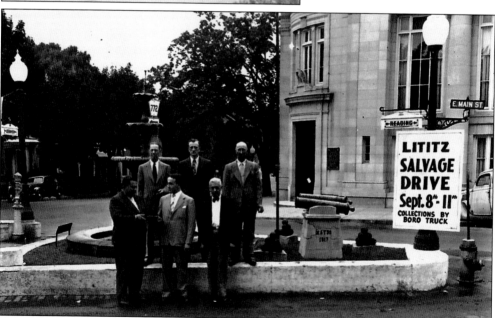

Taken during the 1942 campaign for the collection of salvage for the war effort, the councilmen and burgess pictured here were all part of the operation. Seen here are, from left to right, (first row) Christ Nissly, president of the Lititz Chamber of Commerce and chairman of the Lititz Salvage Drive; Menno Rohrer, Esq., acting burgess (mayor); and Councilman Calvert; (second row) Councilmen Harry Way, Elmer Bomberger, and Thomas Steffy. (Courtesy of Ronald Reedy.)

Lititz son George "Bill" Wiegand was inducted into the U.S. Army in 1941 and trained as a radar operator. He served with Battery B, 421st Coast Artillery Battalion in Newfoundland, the oldest battalion, first organized in 1776 by Capt. Alexander Hamilton. Wiegand was transferred to Company G, 159th Infantry in April 1943 and fought in Germany, Belgium, and France under Gen. George S. Patton. When men in his battalion were asked to volunteer to drive fuel and ammunition to the front lines, Wiegand, already serving as a rifleman, stepped up. He felt it was "the fair thing to do," explaining that at that time he had no loved ones back home, while the others did. Wiegand was discharged from the U.S. Army on November 9, 1945, after receiving several medals, including a Bronze Star. (Courtesy of Donna Hammond.)

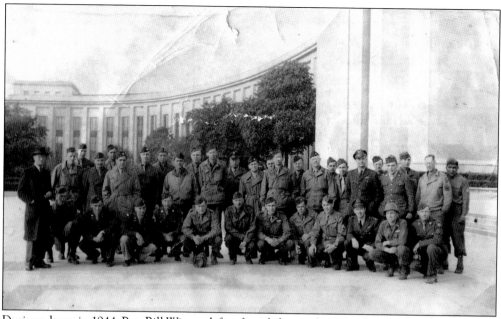

During a leave in 1944, Pvt. Bill Wiegand, first from left, standing, third row, visited the Rainbow Corner, a USO center in Paris. He is shown above with soldiers on leave from various military units. Wiegand was surprised to run into an old friend from Lititz, Pvt. Morris "Mike" Rosenberg, second soldier from left, second row. The men spent time together recalling war experiences and their hometown of Lititz. (Courtesy of Donna Hammond.)

Robert "Bob" Longenecker served as a captain in the U.S. Army Signal Corps during World War II; upon returning from the war he ran his own talent agency, started Tele-Pak (a film production company), and served as vice president of the Academy of Television Arts and Sciences. He also produced the Emmy Awards Show for five years and hosted his own late-night television show in Los Angeles. (Courtesy of Lititz Moravian Church.)

Men and women left their peaceful lives to defend their country during World War II. Some returned; some did not. Esther Ober, right, and an unidentified friend stand in front of the Lititz Post Office where an honor roll had been placed, which listed the names of those Lititz citizens who were serving or had served in World War II. A star in front of a name represented those who were killed in action. (Courtesy of the Robert "Sketch" Mearig collection.)

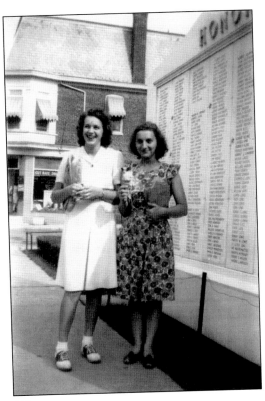

A veteran of the 79th Division, U.S. Army, Pfc. Robert E. Haines, shown here at age 20, served in the Africa, Italy, and European campaigns. He was on the first landing craft to hit the beaches of Normandy on D-Day and was later wounded. He received the Purple Heart and the Bronze Star. Before serving, he assisted his father at the Lititz Springs Pretzel Company. (Courtesy of Lititz Moravian Church.)

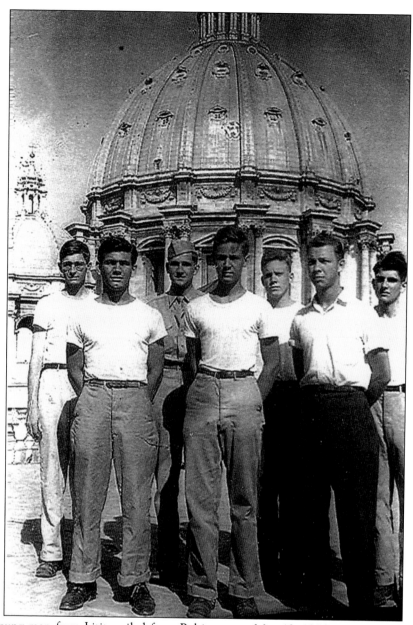

Seven young men from Lititz sailed from Baltimore on May 13, 1946, to serve as "sea-going cowboys," in cooperation with the United Nations Relief and Rehabilitation Administration. Dubbed the Heifer Project, the goal was to replenish farm animals such as horses or heifers that had been killed in war-torn Europe, thereby providing milk and assistance for the children and their families. Participants were from all faiths, and every man had the same goal—to help people whose lives had been torn apart by war. After completing their mission of delivering the animals and several hundred tons of soap and other articles donated by American groups, the men from Lititz had the opportunity to enjoy traveling throughout Naples and Rome and were granted a meeting with the pope. Seen from left to right are James Dietrich, Stanley Schoenberger, Stanley Dietrich, Harry Badorf Jr., Jene dePerrot, Richard Waltz, and Kenneth Dietrich. (Courtesy of Claire dePerrot.)

Six

PICTURE PERFECT MEMORIES

History and memories are eloquently intertwined in photographs. The pictures in the following chapter help to present an enjoyable glimpse of a small Pennsylvania town that has successfully moved into the future by holding tenderly to its past. Life in Lititz is reflected in these compelling images, showing a town that even today remains unique in its beauty and its people who are filled with hope, energy, and pride.

Through the years, historians of Lititz have taken great care to photograph and document some of this town's incredible beginnings to its success as a thriving United States small town. Lititz has stayed adamant about retaining a downtown that does not rely on large, big box superstores but instead has learned how to remain self-sufficient by supporting community businesses in the downtown area. This has allowed Lititz to continue to be a place of peace and serenity, a haven to unwind, relax, and renew the spirit. The following photographs show images of cherished traditions and holiday celebrations unlike any across the nation. The most important images are of the people of Lititz for it is they who have made the town what it is today.

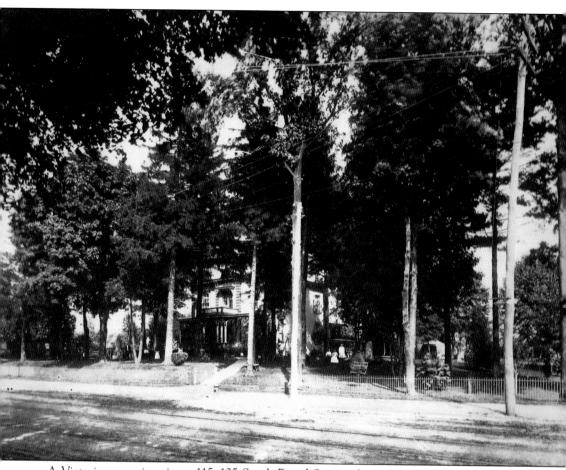

A Victorian mansion sits at 115–125 South Broad Street, above, built in 1868 as Abraham R. Beck's Beck Family School for Boys, educating the sons of socially prominent families from the United States and Europe. The school closed in 1895 and was purchased in 1896 by Dr. James C. Brobst, owner of the Inland Chemical Company, a drugstore at 23 East Main Street. Brobst reopened the stately building as the Lititz Sanitarium. In the early 1900s, Henry J. Pierson purchased the property. Pierson began his political career as president of Lititz Borough Council in the 1920s, became a Pennsylvania state senator in the 1930s, and was president of Consumers Box Board and Paper Company, located along Water Street. He resided in the home until his death in 1953, after which the home remained vacant as part of the Pierson estate until the 1960s, when it was purchased and became known as Audubon Villa, a nursing home. (Courtesy of James Nuss.)

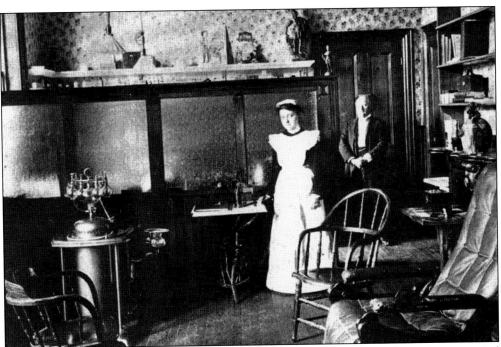

The Lititz Sanitarium was a secluded retreat in the early 1900s for those suffering from a myriad of problems, as evidenced in its brochure: "Our institution is replete from top to bottom with devices and appliances for the cure of all chronic diseases, such as catarrh, rheumatism, kidney disease, gout, and all nerve and blood diseases." It also added that many of the guests did not require treatment but were welcome to enjoy the relaxing beauty of Lititz. "The location is salubrious—pure air, pure water, a porous and well drained soil. The Sanitarium is located on the highest point, overlooking the beautiful Summer Resort Springs and Lititz Creek, which is noted for its famous trout fishing; is composed of beautiful and convenient buildings, and largely shaded with pine and other rare trees." (Courtesy of James Nuss.)

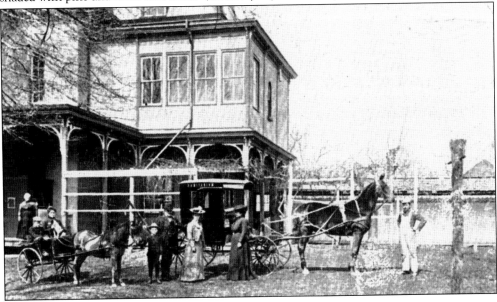

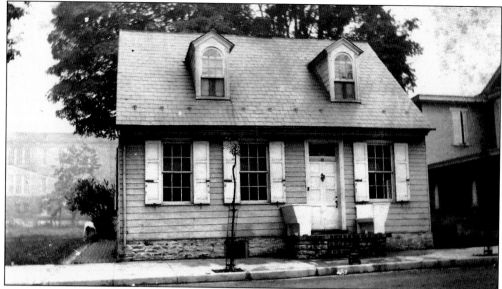

The house seen above, at 66 East Main Street and built in 1762, was the seventh private home built in Lititz. Locals referred to it as the Werner House, referring to its original owner, John William Werner, the town cooper (barrel maker), bleeder (blood-letter) and tooth-drawer (dentist). A unique feature in the house is a two-faced clock created by William Henry Hall of Lititz, built into the wall between two rooms. In over 245 years, the house has been sold only twice; in 1962, the home was willed to the current owner, Peggy Jones. It was placed on the National Register of Historic Places in 1984. Below is a dreamy glance back at a slower-paced day during the 1890s. The Werner House sits to the right through the trees as Alice Boecker strolls by. Sitting on the porch is a very young Robert Huebener. (Courtesy of Peggy Jones.)

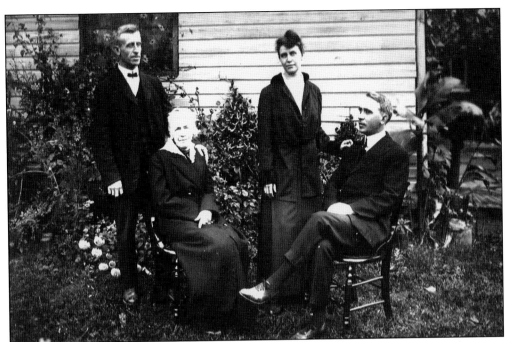

Seen in the *c.* 1910 photograph above, Mary Lichtenthaler Huebener, seated in front, became a widow early in life. To support herself and her children, Louis, left, Mary Augusta, right, and Robert, seated, she ran a store out of her home at 66 East Main Street. Mary died in 1914, leaving the house to her children. Her daughter, Mary Augusta, right, later undertook the daunting task of researching and writing about Lititz's early history, penning the book, *An Early History of Lititz* and in 1949 wrote *History of the Moravian Congregation of Lititz, Pennsylvania.* (Courtesy of Peggy Jones.)

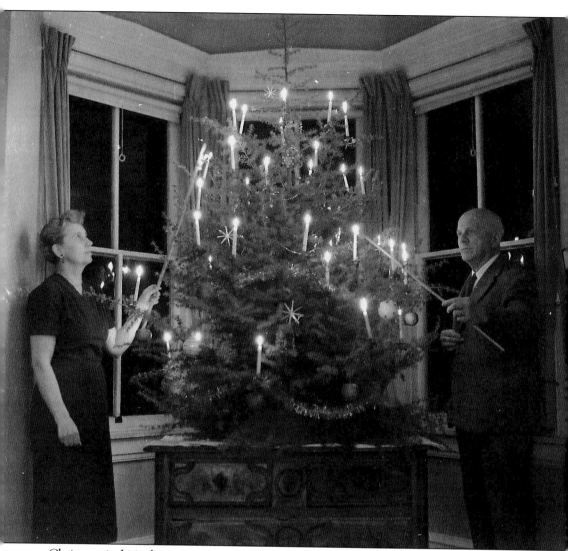

Christmas in Lititz brings many scenes that touch the hearts of everyone. One example is the DePerrot home on Moravian Church Square, above, where a live Christmas tree with lighted candles is placed in the bay window. Blanche and William dePerrot brought the tradition with them from Neuchatel, Switzerland, in 1927. The tree is lit on the Sunday before Christmas. The candles are burned for three hours at a time and then are replaced with new candles. This tradition is now continued by the DePerrot's daughter, Claire, who lights the candles several times during the holidays. (Courtesy of Claire dePerrot.)

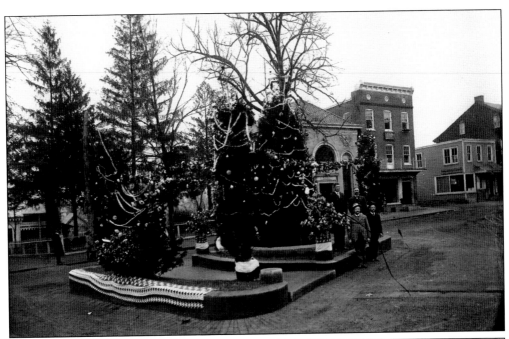

Decorating the town square began in 1915 as a cooperative effort of the borough and the townspeople; the borough furnished several trees, and the citizens provided the decorations, above. In 1973, Lititz Memorial Square began to display a crèche, right. In 1993, a visitor traveling through Lititz saw the crèche and believed that having a religious display on public property presented a constitutional violation. The visitor contacted the American Civil Liberties Union and the fight was on, making national news. Lancaster attorney John Pyfer was hired by the townspeople in an effort to keep their beloved nativity scene. He stunned everyone with his findings by proving that the tiny plot of land on which the crèche sat was still owned by the Moravian Church; therefore, the crèche certainly could remain. The crèche continues to this day as a beloved tradition. (Above, courtesy of Ronald Reedy; right, courtesy of Lititz Historical Foundation.)

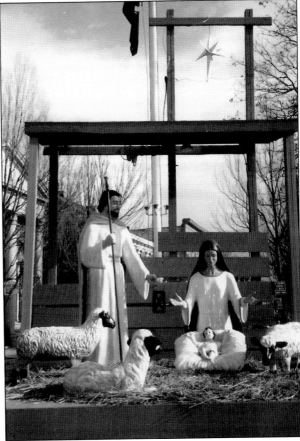

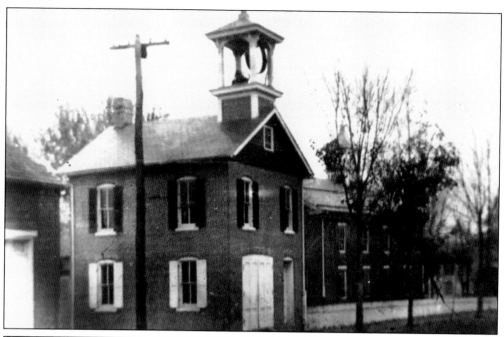

The original Lititz Borough Hall, above, shared housing with the Lititz Hose Company, located along East Orange Street midway between South Cedar and South Broad Streets, on the north side. The land was leased from the Lititz Public School and was first occupied by the borough on February 26, 1894. The borough occupied the second floor, and Lititz Hose Company occupied the first floor. This stately building at 7 South Broad Street, left, designed by architect Henry Shaub, was the second firehouse built in Lititz on the original site of the Wabank House, which burned to the ground in 1873. Built in 1917, it was renovated and now serves as the Lititz municipal building, housing borough hall and the Lititz Police Department. (Above, courtesy of Ronald Reedy; left, courtesy of the Robert "Sketch" Mearig collection.)

This graceful fountain was given to the town in 1895 by Dr. Peter J. Roebuck as a memorial to the Lititz veterans of the Grand Army of the Republic. It was placed on the town square where it remained until 1950, when a new memorial replaced it. The Roebuck fountain was removed for renovations but never returned; it was later sold to an antique dealer. Lititz resident Ada Leed found the fountain, purchased it, then returned it to Lititz. After sitting in the Lititz Historical Foundation's gardens, right, for a time, it was eventually placed—and now resides—in the courtyard of the General Sutter Inn. Below from left to right are Richard Vetter and Mrs. Vetter, both owners of the General Sutter Inn at that time; Ada Leed; Dr. Byron Horne, Lititz historian; Mayor Raymond Reedy; and Rev. Jacob Frederick. (Courtesy of Lititz Historical Foundation.)

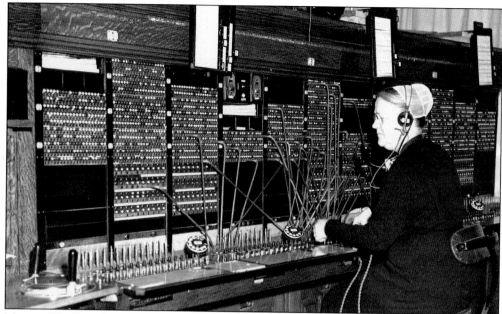

Miriam Weidler, above, demonstrates the maneuvers required of the telephone switchboard operators in the 1940s in Lititz. The telephone office was located in a small building at 136 East Main Street. Below, Anne Sweigart, right, looks on as D&E Communications telephone technician Bill Bingeman, center, installs the 2,000th telephone in Lititz for landmark customers Bette and Robert "Sketch" Mearig, left. Sweigart's father owned D&E Communications at the time, but after starting in her father's company as a telephone operator, she became president and chief executive officer on July 22, 1985. On November 1, 2004, she retired from her position as chairman of the board and president of D&E Communications and was elected chairman emeritus of D&E Communications, a position she held until her death in 2007. (Courtesy of the Robert "Sketch" Mearig collection.)

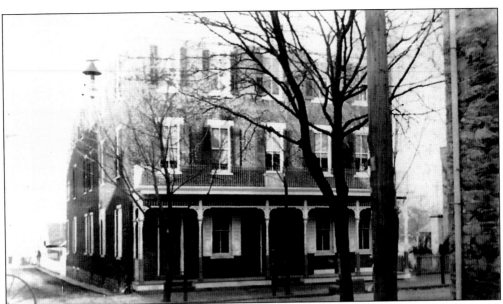

Edward Sturgis, 34, was called to duty in the Civil War, serving with Neven's Independent Battery I. Upon his return, Sturgis's father convinced him to go into the booming hotel business and helped him get his start. He built the two-story hotel seen above in 1867 to serve the needs of the wealthy that visited Lititz. In 1895, a third story was added. In the ensuing years, Harry Chertcoff purchased the building and spent $60,000 in 1935 to change the hotel into a movie theater. Today it is home to Gypsy Hill Gallery, which offers designer crafts, unique music, and fine art. (Above, courtesy of the Robert "Sketch" Mearig collection; below, courtesy of Randy Miller.)

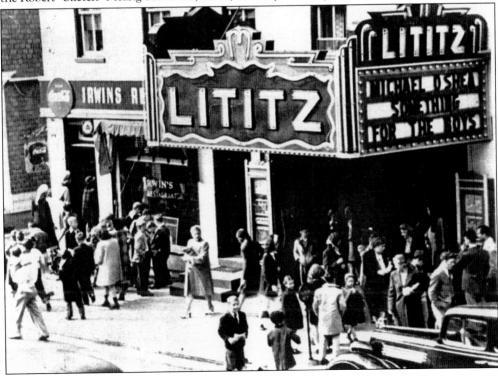

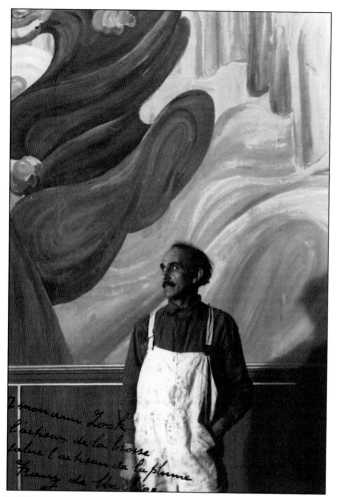

Originally from Ghent, Belgium, artist Franz deMerlier studied art at several academies throughout his life. It was not until at age 52 and that he had moved to Chaddsford, Pennsylvania, that he began painting in earnest. DeMerlier became a local art celebrity through the patronage of the Wyeth family. In 1935, DeMerlier (left) was invited to Lititz to create paintings in several businesses, including the new movie theater. DeMerlier's original paintings on the walls of the movie theater remain intact, cleaned and lovingly repaired throughout the years. Visitors to Gypsy Hill Gallery can view the lovely old paintings as they tour through the gallery. It is interesting to note DeMerlier's identification with the impasto (heavily textured) technique, which is strongly reminiscent of the impressionist movement. (Courtesy of the Robert "Sketch" Mearig collection.)

The Young Men's Business League was a nonpolitical organization that began in 1914 by a group of men who wished to serve the Lititz community by supporting economic development and by addressing the concerns of the townspeople. They continued their community efforts until 1928 when a formal chamber of commerce was formed. Today the Young Men's Business League remains a respected community institution, meeting at 4 South Broad Street, shown at right during World War II. It was this organization that was responsible for encouraging the Stiffel-Freeman Bank Company to relocate to Lititz from Philadelphia in 1915, which boosted the local economy and provided jobs for dozens of Lititz residents, below. (Courtesy of the Robert "Sketch" Mearig collection.)

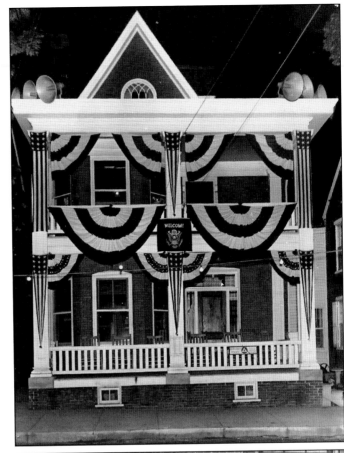

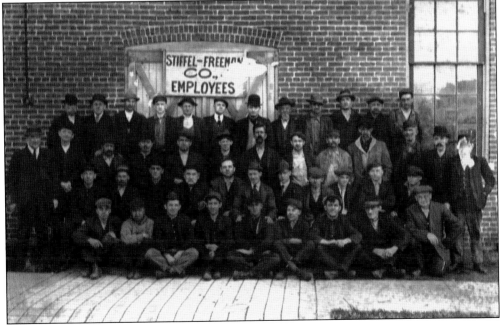

Dr. Alonzo Long, left, had a dental practice at 19 South Broad Street during the mid-1900s. The cost to go to a dentist at that time was prohibitive in most cases; routine, six-month exams did not exist, just a visit when a toothache occurred. Often goods from the garden or the chicken house would be used as payment. Dr. Long is shown here with friend Nathaniel Sturgis, son of Julius Sturgis. (Courtesy of the Robert "Sketch" Mearig collection.)

Nelson Mearig, left, Charlie Kissinger, center, and Billy Kissinger always got their limit on the first day of hunting season. Charlie, seen here in the 1930s, was one of the town characters. He lived with numerous cats and was considered a "poor soul," usually appearing poverty stricken. Those acquainted with the real Charlie knew him as the boy who graduated first in his class in high school. (Courtesy of the Robert "Sketch" Mearig collection.)

One August day in 1914, neighbors and family members gathered on the property of Hayden H. Bomberger to join in a barn raising. The barn, the most expensive and most difficult structure to build, is the first building a farmer needs. Community members come together to assist each other to this day. The photograph above shows that the event began with a filling meal and a prayer of thanks. (Courtesy of the Robert "Sketch" Mearig collection.)

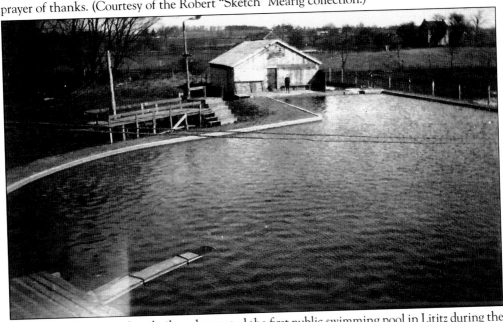

Lititz native Benjamin Lutz built and operated the first public swimming pool in Lititz during the mid-1930s in the northeast section of Locust Street. The pool served the families of Lititz well by including a baby pool and a grandstand for families to watch their loved ones. Admission was 10¢, but for those less fortunate who could not afford the fee, Lutz welcomed them free of charge. (Courtesy of the Robert "Sketch" Mearig collection.)

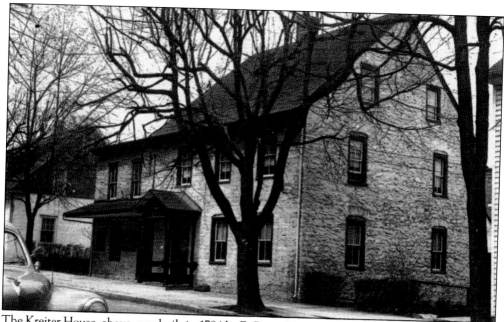

The Kreiter House, above, was built in 1784 by Er Bauet Von Peterkreiter at 219 East Main Street. In 1861 Julius Sturgis, after apprenticing with baker Henry Rauch, moved into the stone house to open his own pretzel bakery. He added a second story to the west and a first story addition, as well as a one and two story factory in the rear. The building is listed on the National Register of Historic Places as the first commercial factory for pretzel manufacturing in the United States. Today it is operated as the Julius Sturgis Pretzel Bakery, one of the top tourist destinations in Lancaster County. (Courtesy of the Robert "Sketch" Mearig collection.)

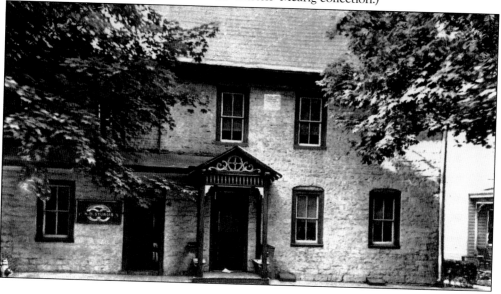

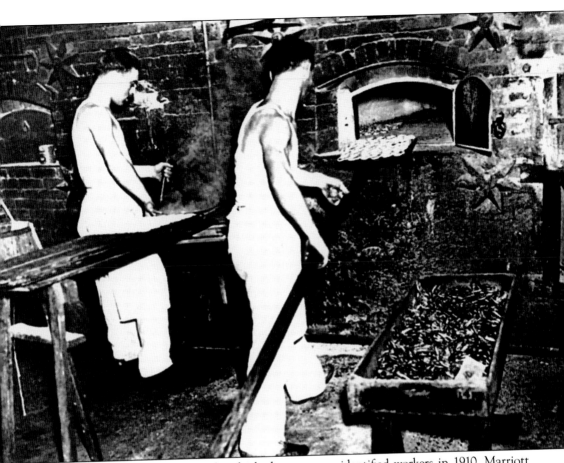

About the time of this photograph, which shows two unidentified workers in 1910, Marriott Sturgis, grandson of Julius Sturgis, was born. Working before and after school in the Lititz bakery that his grandfather had established, Marriott learned much about the family business. At age 14, Marriott's family moved to Reading. First working in another pretzel bakery run by his cousin Victor, Marriott eventually partnered with his brother Correll and opened a pretzel bakery called Sturgis Brothers, but this closed in 1942. In 1946, Marriott, nicknamed Tom, opened his own business under the name, Tom Sturgis Pretzels, which is still in business today, run by Marriott's son Tom Sturgis Jr. and his grandson Bruce Sturgis. The Sturgis family also manages the Julius Sturgis Pretzel Bakery in Lititz. (Courtesy of Ronald Reedy.)

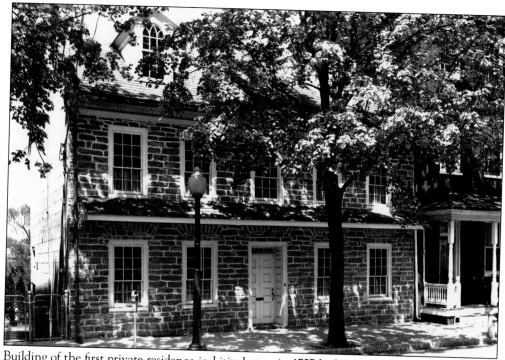

Building of the first private residence in Lititz began in 1757 by Louis Cassler, a shoemaker and tanner. Regarded as the finest house in Lititz in the early years, the handsome old building still stands today at 121 East Main Street, virtually unchanged thanks to a restoration in 1953 by the late Carl W. Drepperd. It is currently a private home and on the National Register of Historic Places. (Courtesy of Lititz Historical Foundation.)

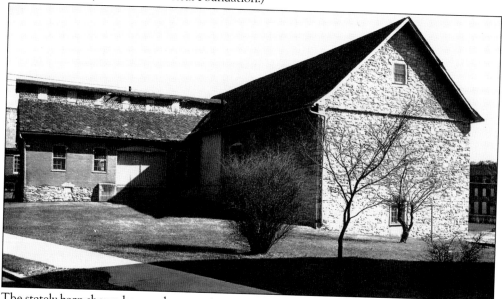

The stately barn shown here no longer exists in its entirety. Now all that remains of the structure is the limestone foundation, on top of which sits an apartment building. It was once the original barn of John George Klein, the early settler who donated his land to the Moravian Church, which made the building the oldest edifice in Lititz. (Courtesy of Lititz Historical Foundation.)

Rolling Hills Girl Scouts, which included girls from Lititz, Rothsville, Hopeland, and Brickerville, were transported by Mr. Hopkins's truck in the mid-1940s to attend Furnace Hills Camp. Older scouts would remain at the camp for the week, while the younger girls rode home each evening. The scouts enjoyed various activities such as hiking, camping, swimming, and campfire cooking. (Courtesy of Claire dePerrot.)

The fertile farmland in and around Lititz often proved to be a splendid playground for families on sunny afternoons. Seen here in a family photograph on November 25, 1935, is Blanche dePerrot with her son Jean, upper left, and her daughter Claire, upper right. The DePerrot family moved to Lititz in 1934. During wartime Blanche was a faithful air spotter, trained to spot and report enemy planes. (Courtesy of Claire dePerrot.)

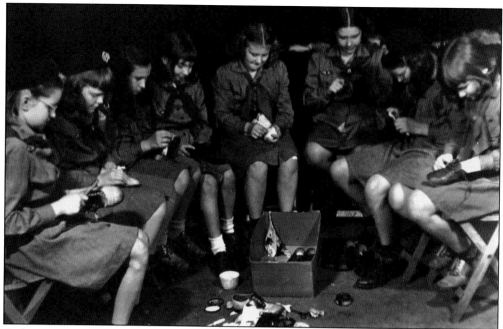

Girl Scouts began in Lititz in 1938 with five members and grew to 12 troops by 1956, which were known as the Rolling Hills Neighborhood. The girls were involved in many community activities, including participating, along with more than a million Girl Scouts nationwide, in assembling and shipping 100,000 clothing kits for children in foreign countries. Above a few of the Scouts are shown cleaning donated shoes that they would later send to France. Below, the girls worked feverishly during a "clean up the park" event in Lititz Springs Park during the summer of 1949. Today there are seven Girl Scout troops in Lititz. (Courtesy of Claire dePerrot.)

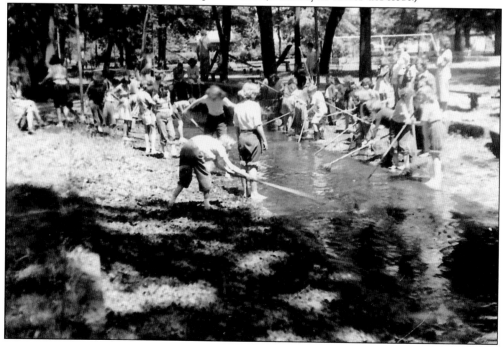

This beautiful young woman is Lottie Spangler, born Lottie Wagaman, who married Paul Firestone Spangler, youngest son of Emma "Mammy" Spangler, a beloved member of the Lititz community for 89 years. Lottie and Paul met at Simplex Box Company as employees, fell in love, and were married. Although they had no children, they did raise Lottie's sister's son and daughter. (Courtesy of the Robert "Sketch" Mearig collection.)

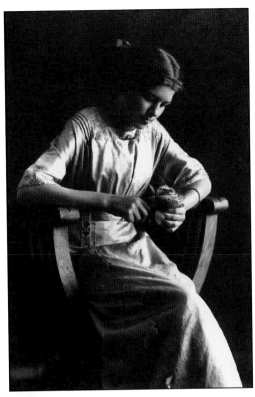

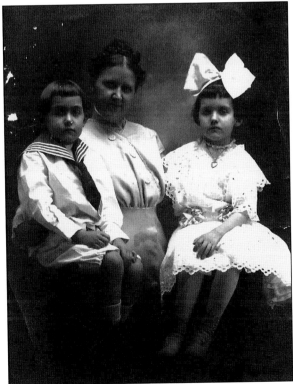

Annie Jenkins, center, was the community midwife to many Lititz mothers during the early 1900s. She is shown here with her son David, left, and her daughter Dorothy, right. Except for one woman, Barbara Snyder Musser, no one knew how Annie was paid. Each month the wealthiest man in Lititz, who wished to remain anonymous, would give Annie's salary to Barbara to give to Annie on a weekly basis. (Courtesy of Gladys Crowl.)

His name was Henry Snavely, but those who knew him referred to him as "Henner," a very beloved Lititz character. Seen here on December 19, 1935, he is doing what he loved the most, acting as auctioneer for household sales. "Hear ye, hear ye," Henner would begin each sale. In this photograph, Henner holds an old-fashioned boot jack, used for prying off boots. (Courtesy of the Robert "Sketch" Mearig collection.)

Art Evans, left, and Elwood Ritz, right, rode the first Indian motorcycle down the quiet streets of Lititz. They are seen standing in front of 15 South Cedar Street, where the present-day D&E Communications building is located. (Courtesy of the Robert "Sketch" Mearig collection.)

Raymond S. Reedy, above left, served as Lititz postmaster, Lancaster County treasurer, Lititz mayor, was a Lititz retailer and insurance broker as well as being active in many civic and fraternal organizations. On July 19, 1981, Gov. Dick Thornburg arrived in Lititz Springs Park for a program that marked two anniversaries—the 225th anniversary of Lititz and the 300th anniversary of the granting of the Pennsylvania Charter to William Penn. The governor presented a proclamation to Mayor Reedy telling those in attendance, "the smaller towns have formed the real backbone of what has come to be the Pennsylvania way of life." Because of his passion of football and baseball, during the late 1940s and 1950s, Reedy was the public address announcer for the local high school football and baseball games. (Courtesy of Ronald Reedy.)

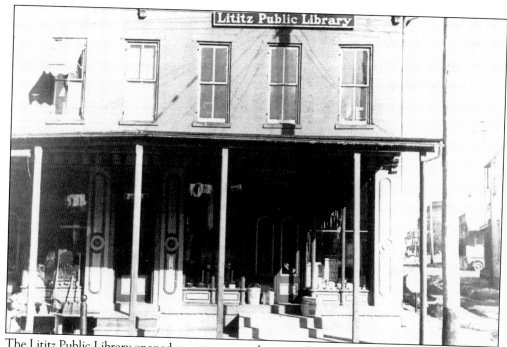

The Lititz Public Library opened on a temporary basis on the second floor of the Amer building in 1936. When the library moved into the Lititz Public School in 1940, the number of available books doubled. In 1961, the library moved into another temporary site, the General Sutter Inn, until 1964. After two more moves, the Lititz Public Library made its final move in 1999 to 651 Kissel Hill Road. (Courtesy of Randy Miller.)

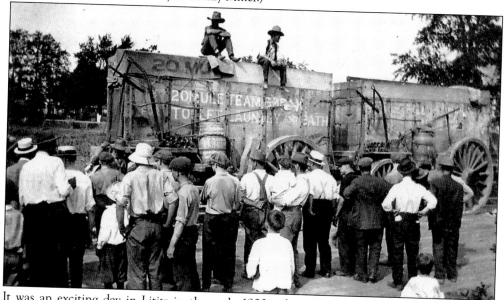

It was an exciting day in Lititz in the early 1900s when the famous "20 Mule Team" came through town. Residents gathered eagerly to get a closer look at the historic wagons that had made their way from California's Death Valley. The 20-mule-team wagons were among the largest ever pulled by draft animals. When loaded with borax, the total weight of the mule train was 73,200 pounds. (Courtesy of Randy Miller.)

John Augustus Sutter, founder of Sacramento, California, is pictured on his patio in Lititz. After losing everything in the gold rush of 1849, he relocated to Lititz for the last nine years of his life. Sutter thought Lititz to be a "little German town" with excellent schools for his grandchildren and healing spring waters, and he was pleased that it was close to Washington, D.C. Sutter fought with Congress for more than 15 years to be compensated for the loss of his seized land during the gold rush, but it was to no avail. On June 16, 1880, Congress adjourned without action on a bill that would have given Sutter $50,000. On June 18, 1880, just two days later, Sutter died. (Courtesy of Dale Groff.)

GENERAL JOHN A. SUTTER

First Gold in California was discovered in 1848 on his ranch. Gold hunters despoiled his property and he died before Congress did anything to restore it. His age was 77 and he is buried in the northeast corner of the Moravian graveyard at Lititz. His last home was at 17 East Main Street

EXPRESS PRINTING CO.

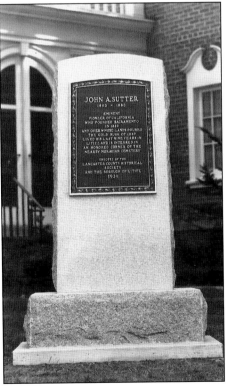

John Augustus Sutter's son paid the cost of $10,000 to have this home built for his parents. The centralized location allowed Sutter to stay aware of the town's activities. He proudly boasted that his was the first house in Lititz to feature indoor plumbing for both hot and cold water. The structure is a two-and-half-story, gable-roof brick house, measuring 30 feet wide by 42 feet deep and has brick chimneys at each gable end. Sutter was also proud of the windows, which were two over two, double-hung sash, painted white, and two panel green shutters. This was, he would point out, a statement of wealth at that time. The home at 19 East Main Street is not open to the public. (Courtesy of Randy Miller.)

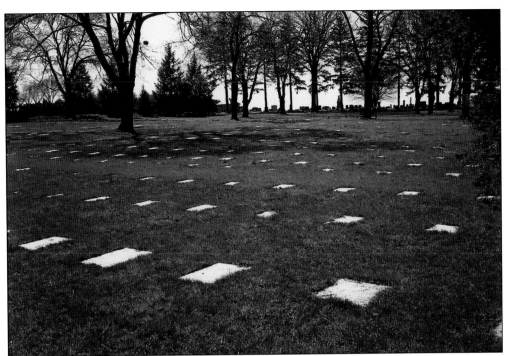

In the original Moravian graveyard, "God's Acre," above, small, flat, white gravestones symbolize the equality of all after death. One grave site differs—that of General Sutter. Years after Sutter's death, the United States government decided to honor the general by erecting a seven-foot, solid marble boundary marker around his grave. Anna Hull, Sutter's granddaughter, tried in vain to stop it from being installed, as it would not be in keeping with the guidelines of the Moravian cemetery. After much thought, she contacted the government and invited them to bring the marble slabs to the grave site. When they arrived, a six-foot trench was dug around Sutter's grave. When the slabs were placed in them, all that showed was a small, white border of marble as shown below. (Courtesy of James Nuss.)

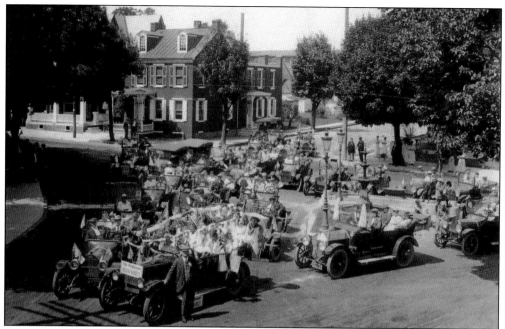

Lititz resident John F. Longenecker, standing center left, organized and led a road rally in 1914. Longenecker began his career with a wagon business that later evolved into several car dealerships in Lancaster County, one of which was located in Lititz. His thriving businesses ended in 1929 during the Great Depression. Longenecker is seen in this photograph standing by his prized Marion Handley automobile. (Courtesy of Randy Miller.)

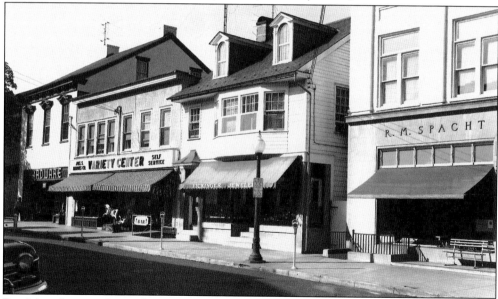

East Main Street in Lititz, shown above around 1956, looks like a movie set with sparkling clean streets and sidewalks, which is as true today as it was then. This view shows the north side of Main Street with Gen. John Sutter's home on the left at 17 East Main Street, then Harris Variety Store at 21–23 Main Street, Fickinger's Jewelry store at 25 Main Street, and Spacht's at 27–31 Main Street. (Courtesy of the Robert "Sketch" Mearig collection.)

Buchter's Barbershop was owned by Harry Buchter, right, who ran the shop for 30 years at 6 South Broad Street. He was later joined by his son, Eugene, below on the right, making it a one-of-a-kind father-son enterprise in Lititz. They are shown here cutting the hair of the third generation of Buchters, Donald, left, and Douglas, right. Eugene passed away in 1978, but Harry continued the business until 1982. (Courtesy of Thelma Buchter.)

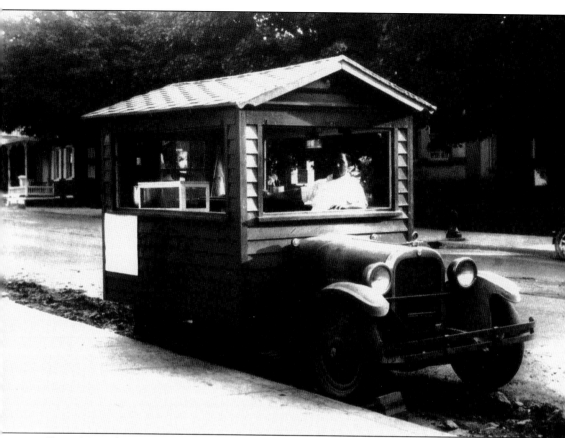

Rosey's Lunchwagon, a tradition in Lititz, began in 1922 with a wheelbarrow covered with green burlap. Times changed and so did the vehicle; the wheelbarrow was replaced by a milk delivery wagon, which sufficed until the horse went blind. A pickup truck was then used to tow the milk wagon until Arthur "Rosey" Rosenberg, pictured above, revamped a 1923 Dodge touring car, a common site along Broad Street, 1930–1948. Rosenberg's son, Bob, who had worked with his dad since age 12, took over in 1956. Rosey's Ice Cream was always a hit, but it was the delicious hamburgers that were the "do not miss" item; the secret recipe has never been made public. Rosey's Lunchwagon was sold to a new owner in later years but continues to serve the Lititz community every Saturday on Broad Street. (Courtesy of Marion Weaver.)

Lititz Springs Park has remained a breathtaking monument to the pride of its town. The photograph at right is one of the earliest pictures known to exist, taken sometime during the 1800s. The park is still owned by the Moravian Church; however, a declaration of trust was signed in 1956, putting management and operation of the park in the hands of a 12-member board of trustees comprised of representatives of various local churches and several members-at-large. Upon the arrival of the railroad in 1863, outsiders from surrounding areas traveled to Lititz on a regular basis. From the park's earliest days, it has served the community unfailingly, offering not only its natural beauty as a respite from the day-to-day routine but as an area in which families can enjoy many fun-filled outings. (Right, courtesy of Ronald Reedy; below, courtesy of the Robert "Sketch" Mearig collection.)

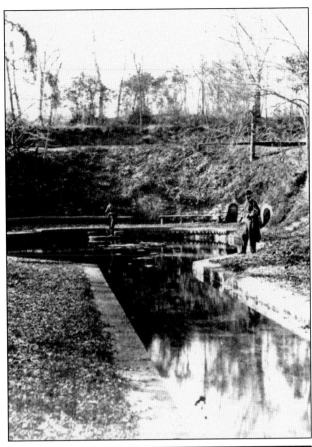

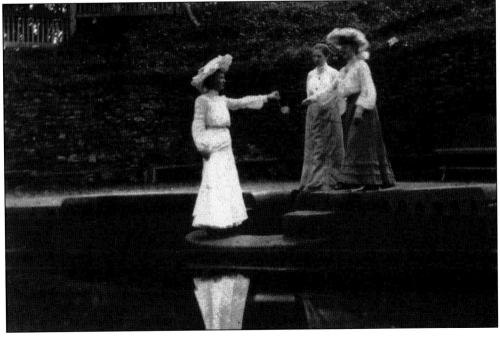

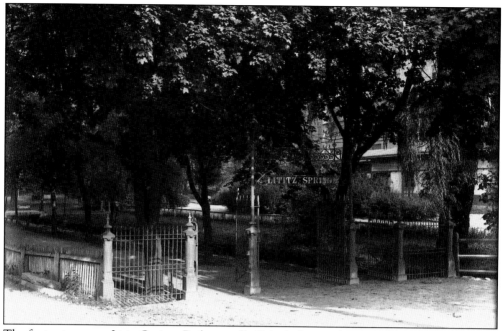

The first entrance to Lititz Springs Park was off of Maple Street; the second entrance, seen here, was developed in 1884. This early-1900s photograph of the second entrance to Lititz Springs Park was sent as a thank-you note to hundreds of friends of Robert "Sketch" Mearig, recognized as the town's premiere historian. (Courtesy of the Robert "Sketch" Mearig collection.)

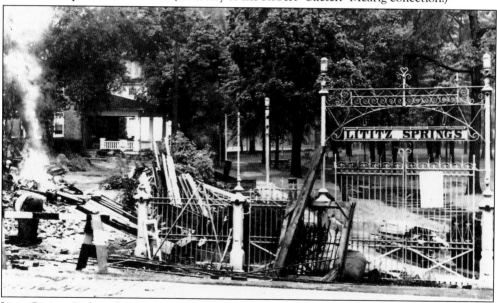

Lititz Springs Park underwent extensive improvements after a visit in the summer of 1956 from Lititz native Elmer H. Bobst, chairman of the board of the Warner-Lambert Pharmaceutical Company. An internationally known philanthropist, Bobst reached out to his hometown, donating $100,000 for renovations to the park. In 1957, demolition began, seen above, to begin the beautification and modernization of the entrance to the park. (Courtesy of the Robert "Sketch" Mearig collection.)

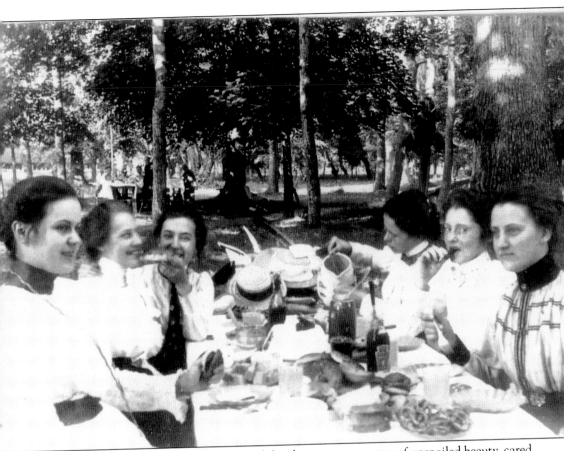

Shown here in the 1880s, Lititz Springs Park has become seven acres of unspoiled beauty, cared for by volunteers and managed by a board of trustees. Today it is a place of peace and reflection. The park is the site of the longest continuous celebration of the Fourth of July in America; in August it is home to one of the East Coast's largest craft shows, with approximately 50,000 people attending. At Christmas, Santa and Mrs. Claus are on site each weekend in the park's caboose to welcome the youngsters of Lititz. The park offers two playgrounds, three covered pavilions, a sand volleyball court, a gazebo, a band shell, and a canal that holds water from three underground springs. (Courtesy of Randy Miller.)

The Fourth of July parade in Lititz has always been a grand occasion with a dizzying array of floats, trucks, fire equipment, and bands. In 1920, Eugene Longenecker (above, left) and his father, John, are shown here with a vehicle decorated for the parade, which they advertised as "Longenecker's Road-O-Plane, 1920 model. Two in one." John Longenecker was one of the country's leading distributors of automobiles and was the father of Robert "Bob" Longenecker, a 1928 Lititz High School graduate. Bob went on to earn a degree in commerce and finance from Pennsylvania State University in 1932 and eventually found his way into the world of radio, which led him to Hollywood. It was there that he married movie star Ruth Hussey. Ruth and Bob were married for 60 years. (Courtesy of the Robert "Sketch" Mearig collection.)

Tucked away in a recessed area of the headspring of Lititz Springs Park, John Augustus Beck carved a lion's head into the rock in 1857. In 2005, it was the target of a vandal who obliterated the priceless artwork. In 2006, the town had a full scale Lion of Lucerne sculpted and set into the stone. Beck's other works can be seen on the Washington Monument and in the White House. (Courtesy of Ronald Reedy.)

History is abundantly obvious in Lititz but never so beautifully than in Lititz Springs Park. At right is a natural, bubbling fount nestled among the limestone rocks of the head end of the park's canal. In the early 1900s, Paul E. Beck, his father, Abraham, and his brother Herbert inscribed above it *Gottes Brunnlein hat Wasser die Fulle*, which translated is, "God's fount is never failing." (Courtesy of Ronald Reedy.)

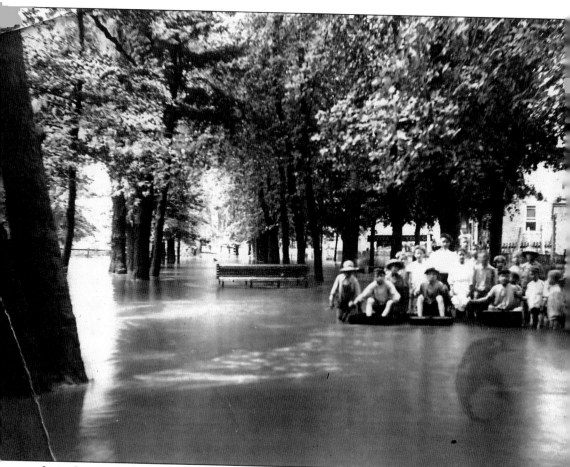

Lititz Springs Park has endured several floods through the years. A central canal runs through the length of the park, channeling the water that bubbles up at the springhead of the park. When unusually heavy rains occur, the icy water swells above the stone borders and the park floods. Each time, the park is lovingly tended to by town residents who volunteer their efforts to bring the beloved park back to its natural beauty. In 1930, shown here, a major flood occurred that gave the local children an opportunity to enjoy a watery afternoon's play. (Courtesy of the Robert "Sketch" Mearig collection.)

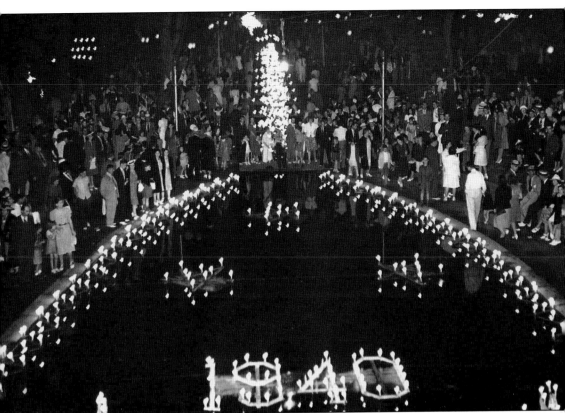

Fourth of July celebrations were sporadic in the early years, but on July 4, 1811, the village band entertained along the "big spring" in the newly developed park for the first time. Although not looked upon favorably by the town elders, it began the annual celebration in Lititz Springs Park that has been presented each year since then, which now brings almost 10,000 people who want to step back in time. Reminiscent of a Pollyanna movie, all events hark back to the good old days, just old-fashioned fun. The most awaited portion is the Fairyland of Candles, shown above in this 1940 view from the head end of the canal. (Courtesy of the Robert "Sketch" Mearig collection.)

The 1843 Fourth of July celebration saw a new addition to the festivities. A breathtaking event took place when 400 candles were lit on the posts of the fence from the fountain to the top of the hill, an idea borrowed from the most familiar portion of the Christmas Vigil of the Moravian Church. In 1844, 1,000 candles were illuminated and fireworks were added. Today the number of candles lit along the canal and into the springhead is a staggering 7,000. Wooden pyramid-like structures, seen at left, that hold the candles are set up by park volunteers well before the event. Children as well as adults help place the candles in their holders the day of the celebration, an act that is viewed by all as a cherished honor. As darkness sets, the candles are lit, offering a spectacular sight. (Courtesy of Lititz Historical Foundation.)

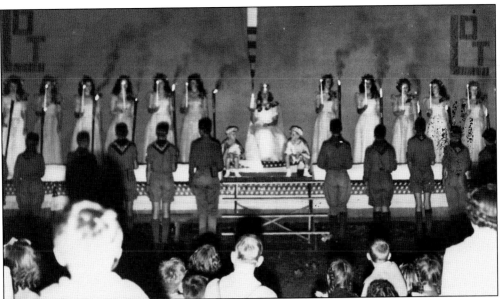

Christened the Court of the Queen of Candles, this Fourth of July ceremony debuted in 1942, as shown above, to complement the celebration of the 100th annual candle illumination. Some 12 Lititz High School senior girls were chosen by their peers to vie for the title of Queen of Candles with the winner divulged the evening of the Fourth of July in the band shell in Lititz Springs Park. Pauline Moyer was honored with the title of the very first Queen of Candles. Boy Scouts' candles were lit from the queen's court at the conclusion, and then used to light the candles, below, that adorned the canal. Because it was so enthusiastically received, the pageant, its type seen nowhere else in the world, has remained a permanent part of the Fourth of July festivities. (Above, courtesy of Ronald Reedy; below, courtesy of Lititz Historical Foundation.)

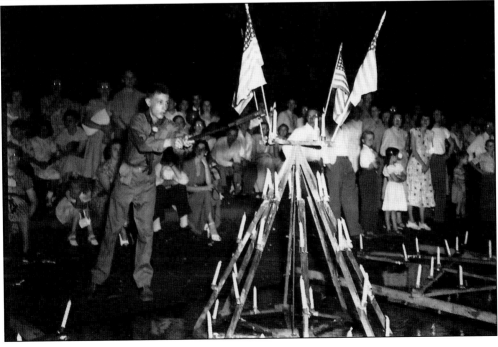

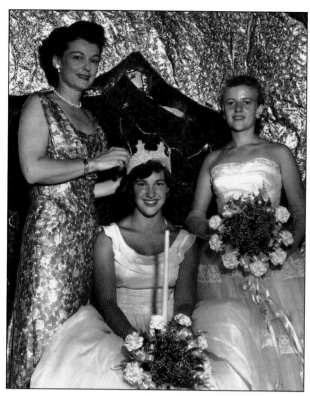

In the photograph at left, distinguished Hollywood movie star and actress of both stage and television Ruth Hussey, left, crowns the 1957 Queen of Candles pageant winner, Susan Beck Smith, center, as Vivian Landis Aichele, the 1956 queen, stands by. Some 15 years earlier, Hussey had married talent agent and radio producer Robert "Bob" Longenecker, below, who had been born and raised in Lititz. They were blessed with three children, Robert Longenecker, John Longenecker, and Mary Liz Hendrix. (Courtesy of Mary Hendrix.)

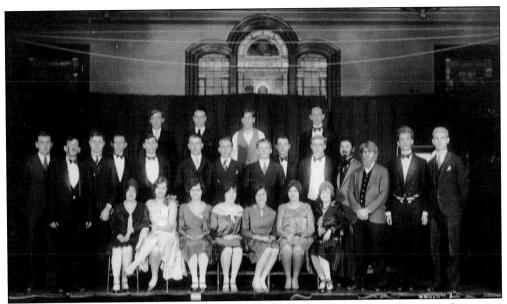

During his high school days in Lititz, Bob Longenecker (above, far left) enjoyed amateur theatrics, shown here in a 1926 high school play. Standing next to Bob in this photograph is Richard Snyder, who later served as a Pennsylvania senator for 22 years. Although Bob's life took him in the direction of producing instead of acting, he became a vital part of the Hollywood elite. In 1937, Bob was helping to produce the radio show *Your Witness*, which was written and directed by Ashmeade Scott, of Mount Gretna fame. Employed as a production manager by Columbia Broadcasting System, a 1938 *Lancaster Sunday News* article stated, "Bob Longenecker was referred to among his associates as, 'Columbia's Ambassador of Goodwill.'" (Above, courtesy of Bernie Hendricks; below, courtesy of Mary Hendrix.)

The year was 1956; the event was the bicentennial celebration in Lititz. Hollywood legend Edward E. Horton, left, was starring in a production at the Ephrata Playhouse and agreed to be an honored guest at the event. The next year Horton starred as Sir Walter Raleigh in the movie *The Story of Mankind*. Horton is best known, however, as the voice of the narrator in the Rocky and Bullwinkle series, although he made more than 120 movies in addition to a multitude of television work. Introducing Horton and the queen of the bicentennial celebration, Lynn Reidenbaugh, is William "Buck" Scatchard Jr., right, one of the original founders of McCloud, Scatchard, Derck, and Edson, which exists today as Derck and Edson. (Courtesy of the Robert "Sketch" Mearig collection.)

On November 5 and 6, 1920, at Lehman's Garage, the first community fair debuted, thanks to the efforts of a group of Lititz men. A poultry show was held in the Lititz Fire Hall and cattle, pigs, and sheep were part of the stock exhibit held at the Warwick House on Broad Street. H. D. Leman and Barbara Snyder, who secured and prepared 325 exhibits, are recognized as the dynamic duo that was responsible for the fair's success. As interest waned and organization became difficult, the last fair was held in 1959. Today Lititz offers an outdoor farmer's market every Saturday morning along North Water Street. (Courtesy of Ronald Reedy.)

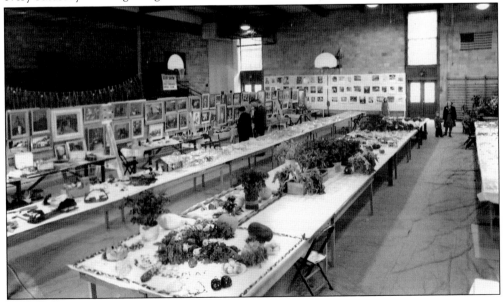

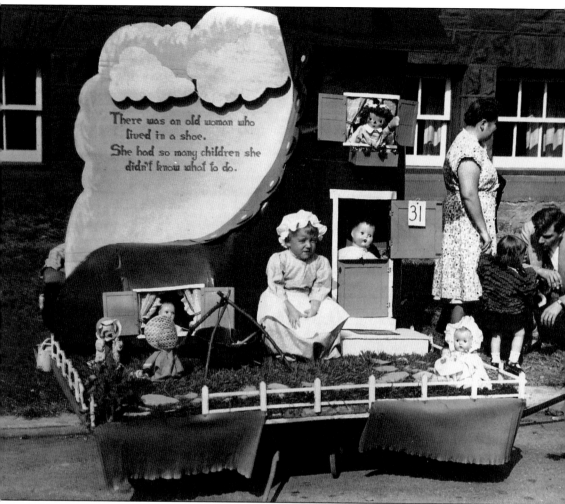

There was an old woman who
lived in a shoe.
She had so many children she
didn't know what to do.

Approximately 10,000 people turned out for the first community fair; it was later incorporated and lasted for 40 years. One of the most anticipated activities during the Lititz Farm Show was the baby parade, much to the delight of the families of Lititz. The baby parade was held on Saturday, October 14, 1950, the same year that the Lititz Memorial Fountain was dedicated. Above is "Old Mother Hubbard," little Carol Groce, anxiously awaiting the beginning of the procession. (Courtesy of Ronald Reedy.)

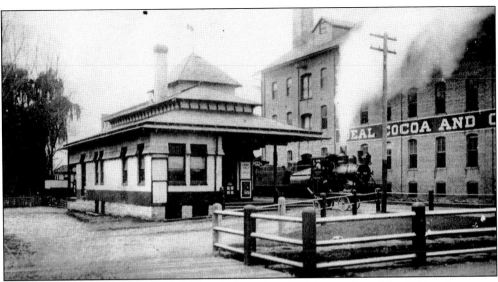

The "new" Lititz Welcome Center, below, dedicated in 1999, is a replica of the 1884 train station, above, that once sat in the same location. Inside guests learn about Lititz, its history, and what it offers today. After a chat with a welcome center volunteer, guests begin their stroll through town. They are mesmerized by the picturesque, tree-lined streets, the charm of the small-town feeling, and the opportunity to enjoy a slower pace, and they appreciate the locals who welcome them warmly. Original buildings along Main Street that date as far back as the 18th century are now enchanting shops, galleries, and eateries. Thousands of visitors flock to Lititz each year to participate in celebrations that maintain traditional roots. Once a little village set apart from the rest of the world, Lititz shines now as Lancaster County's hidden gem. (Above, courtesy of the Robert "Sketch" Mearig collection; below, courtesy of George Sayles.)

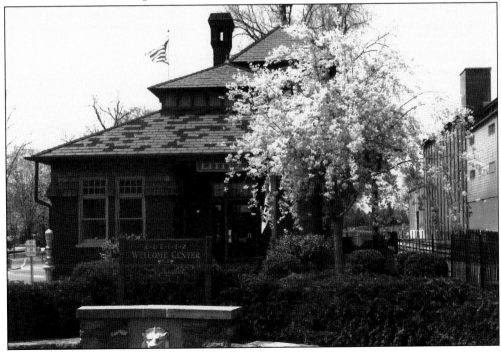

DISCOVER THOUSANDS OF LOCAL HISTORY BOOKS FEATURING MILLIONS OF VINTAGE IMAGES

Arcadia Publishing, the leading local history publisher in the United States, is committed to making history accessible and meaningful through publishing books that celebrate and preserve the heritage of America's people and places.

Find more books like this at
www.arcadiapublishing.com

Search for your hometown history, your old stomping grounds, and even your favorite sports team.

Lititz may be just a speck on the map, but its historical impact is a match for any of the nation's biggest cities. Shaped by history, today Lititz sparkles as the village jewel of Lancaster County. Set against the breathtaking beauty of the surrounding countryside, this little town offers a thriving downtown, slow-paced atmosphere, and abundant recreational areas and cultural events. Lititz is the proud home of Julius Sturgis Pretzel Bakery, the nation's oldest pretzel bakery; Linden Hall, the oldest girls' boarding school in the United States; and the oldest continuous celebration of the Fourth of July. The vintage photographs in *Lititz* present a rare insider's view of a town of historical firsts in America, and they show why visitors always leave Lititz with the feeling of nostalgia for the hometown of their childhood.

Kathy Blankenbiller is an award-winning feature writer and columnist for the *Lititz Record Express* newspaper. She currently serves on the board of directors of the Lititz Historical Foundation and is the creator of the script for the Lititz Main Street Walking Tour.

The Images of America series celebrates the history of neighborhoods, towns, and cities across the country. Using archival photographs, each title presents the distinctive stories from the past that shape the character of the community today. Arcadia is proud to play a part in the preservation of local heritage, making history available to all.

ARCADIA
PUBLISHING

www.arcadiapublishing.com

MADE IN THE

USA

ISBN-13 978-0-7385-6218-6 $21.99
ISBN-10 0-7385-6218-1

52199

9 780738 562186